Savor the North!

Jeff P.

SEASONS OF THE NORTH

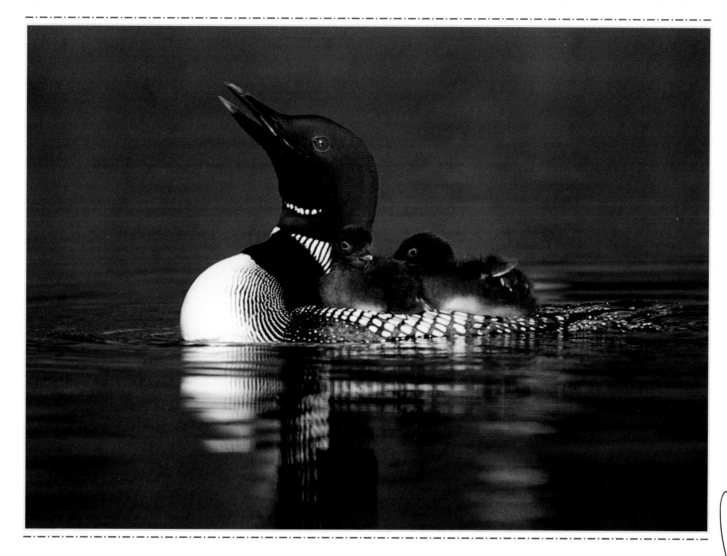

PHOTOGRAPHS BY JEFF RICHTER

WITH ESSAYS BY
JOHN BATES · JUSTIN ISHERWOOD · TERRY DAULTON · CHAD MCGRATH

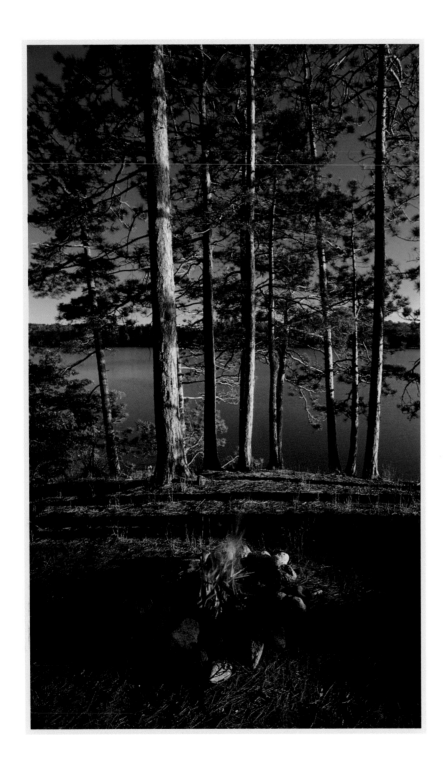

Published by Nature's Press
Jeff and Rosy Richter
PO Box 371, Mercer, WI 54547

Books and prints available at
Nature's Gallery
Main Street
Boulder Junction, Wisconsin
Open mid-May to October

Design and editing by
Linder Creative Services

ISBN: 0-9741883-0-1

Printed in the United States of America

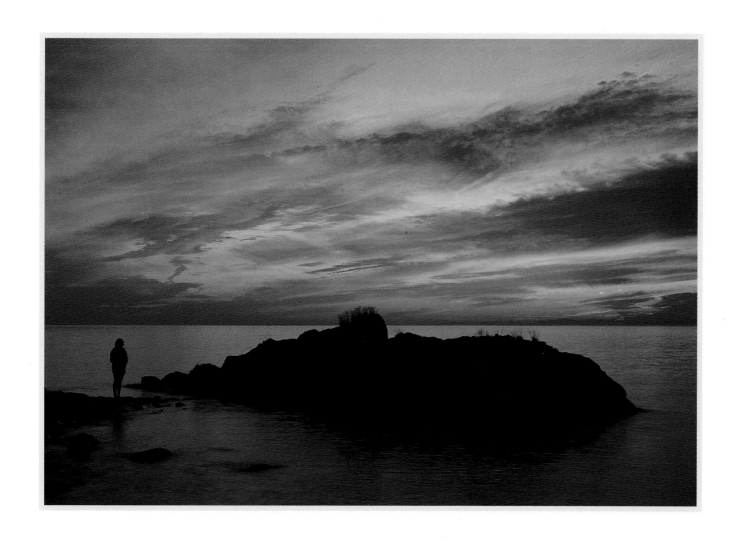

To friends and family who lent support and encouragement.
To all the people who gave their technical and artistic expertise in making this beautiful book.
And to my lovely wife, Rosy, for sharing her life with me.

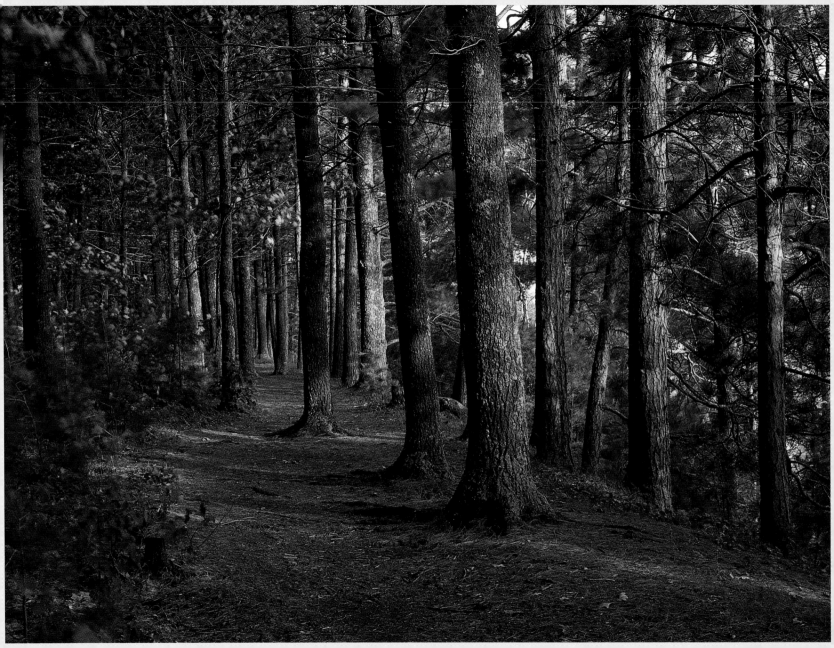

Introduction

The North is full of wonder. Its wild beauty grabbed my attention as a young man, and keeps a grip on me some 30 years later. The vast array of landscapes and wildlife holds unending fascination. From loons to wolves, bears to eagles, the North embraces species that evoke wildness. Species that show disdain for the tamed ecosystems farther south. Species that send a chill up your back when heard or seen on a moon-filled night. Special moments enhance the mystery of life here—such as the sight of a mother bear with cubs in tow, appearing out of the forest and then disappearing as if they were never there.

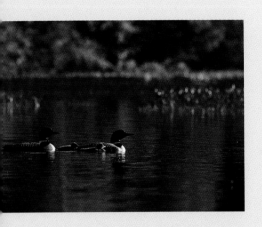

We're blessed in the North with a truly unique landscape. There are only a couple of places in the world that have the concentration of inland water that exists here. Let me say that again—we have a higher proportion of surface water (1,300 lakes in Vilas County, Wisconsin, alone) than almost any other place on the entire globe. What I wouldn't give to have been able to experience this area before the great pine forests were harvested! Nonetheless, the lakes and forests here are a natural treasure without equal, and they provide a seemingly endless supply of subjects to photograph.

My path to photography has been different from most. I've had no formal art training and a minimal amount of instruction in photography. The natural world has been first and foremost the driving force of my vision. From an early age I spent countless hours hunting, fishing, trapping and just exploring the countryside. My love of the outdoors and

fascination with wildlife led me as a young man to a career in trapping. Those years did more to give me an understanding and deep appreciation of the complexity and beauty of the natural world than all the college study I could have endured.

I always said during my years trapping that you need to know animals better than they know themselves, and it's certainly every bit as true when pursuing wildlife with camera and film. I always advise aspiring photographers to spend every available moment afield observing and feeling part of the ecosystems and species they're photographing. Understanding the technical aspects of photography is important, but it's not the most critical element in creating photographs with impact. Go slow, be patient, get ready, and good things will happen.

The process of photographing memorable moments is as varied as the subjects that appear in this book. It may be as simple as walking out the back door to

photograph a monarch feeding on wildflowers, or as demanding as weeks huddled in a blind through every imaginable weather condition, or backpacking for a week on a wilderness island in Lake Superior. Good images are where you find them.

I've been fortunate in my travels to witness incredible moments of drama and beauty. Especially memorable were watching a pack of wolves chase down a bull elk in Yellowstone; bald eagles fighting over a meal within arm's reach of my blind; a summer storm, rumbling its way ever closer. Yet the subtle and simple can produce images that are every bit as dramatic and artistic. I can find as much inspiration in the intricacy of a songbird's feather as a fiery red sunset over snow-capped mountains.

My job, as a photographer, is to find moments of beauty and record them in a visually compelling way. It's hard work. It consumes a lot of time and money.

It requires patience, persistence, and anticipation. The physical, mental and emotional demands are rarely understood by non-photographers. Still, for me it's the greatest job imaginable. I feel compelled to capture a slice of time, an instant of light, or glimpse of wildlife behavior that exposes the soul of the North.

From my point of view it becomes more obvious every day how profoundly we humans affect the whole ecosystem. Most of our lives are distant from the natural community and it's too easy to overlook the impact our footprints leave on this planet daily. It's a mistake to ignore the effects of our actions on the health of the North. A mistake we cannot afford to make if we, residents and visitors alike, are to preserve the qualities people come here seeking—the quiet, the space, sparkling lakes, and wildlife. Ultimately, a healthy ecosystem is not only in the best interest of wild communities but is vital to everyone wanting to live and recreate in unpolluted,

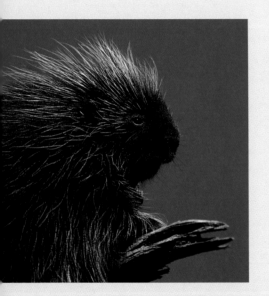

naturally abundant surroundings.

The North belongs to its myriad of creatures, plants and trees as much as to sportsmen and -women, realtors, loggers, lakefront owners and developers. We lose a bit of the the wild Northwoods with every power boat, jet-ski, ATV, and snowmobile we add to the landscape, and every vacation home we squeeze onto a 100-foot lake lot. What a tragedy if we develop and tame the North to the point where our children's children will never experience the magic of its quiet beauty.

To me the North is the glimpse of a wolf, the dance of a loon, the soothing sound of wind in the pines, a tumbling stream full of spawning fish. Recalling a long walk through an old-growth forest, meandering along a Lake Superior beach, or paddling an undeveloped lake, these are the memories and feelings I hope my photos capture. Come along on a journey through the seasons and perhaps you'll feel and remember it, too.

Celebrate the wild.

—Jeff Richter

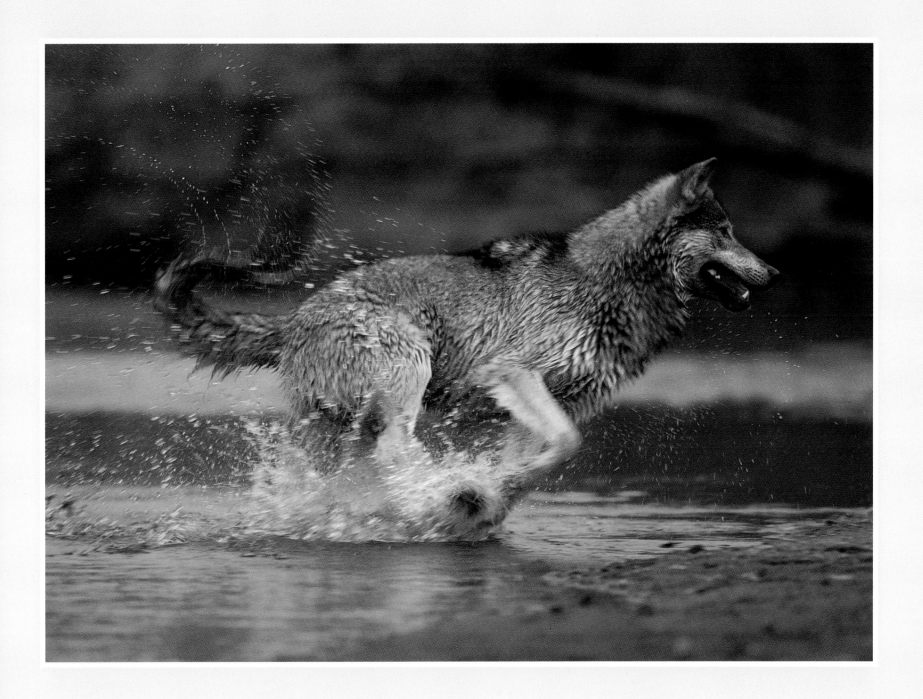

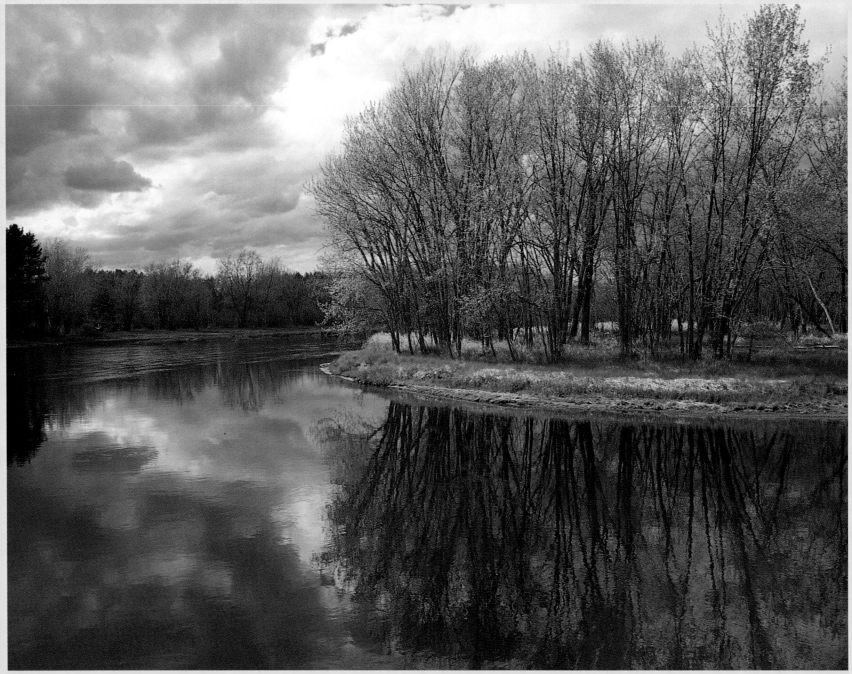

by John Bates

March dazzles the winter-weary, seducing us with rumors of warm sun and flowing water, dominating our daydreams, duping the unsuspicious. Long ago, we learned that March earned its Ph.D. in bait-and-switch advertising. But we forget. March teaches unethical business practices and courses in misguided meteorological musings. A magician builds his toolbox with equal parts smoke, mirrors, and March. Casinos look to March for inspiration in the sale of impossible odds. Why, the shell game was invented in March. And surely Lewis Carroll found his wellspring for Alice in Wonderland in March.

We crust-ski in March, mountain bike on the decaying ice of exhausted snowmobile trails, watch the rivers for signs of weakness, admire our canoes, read summer catalogs, and complain.

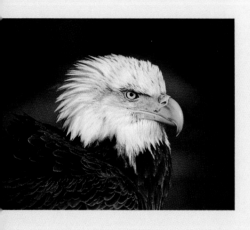

Pre-Easter services are thickly attended by true believers in resurrection, hoping to see Christ and 50°, but willing to settle for either. March chants its name endlessly— we're marching, marching, marching. Spring comes as a long boot camp. Oh, are we prepared for spring! We become hard-bodied, fine-tuned, crazier than the loons who fly daily over the lakes looking for open water, then uttering a solitary tremolo cry and turning back south.

The snow sings its dirge, and we become like Eeyore—dull, depressed, dim, down, desperate. Yes, desperate. Even the snowmobilers, whose lungs must be made of steel, have finally begun to choke on their exhaust and yearn for cleansing winds, have trailered their rigs and assigned them garage berths, have taken down their golf clubs and swing them in their living rooms to the horror of their lamps.

The words "miracle," "resurrection," and "revolution" are written with caution, with full knowledge of their overworked lives in clichéd times. But five months of ice washing away in the floodwaters, the launching of millions of birds with the deepest of Faiths, the Green-Up to come on the heels of the sodden gray heaps of snow that melt, saturating winter into fog, into puddles, into mud, and eventually into the first trailing arbutus, the tiny scarlet female flowers of hazelnuts, and the purple-pink-white -unable-to-decide hepaticas—*that* is a miracle. It is glory.

Moats form around the lake edges, the ice like a pancake in a skillet, and one day the wind rushes from the south and ripples the ice sheet, driving it onto shorelines to slice trees off and buckle the

piers of people who didn't know ice was like slow dynamite—a tornado reduced to a crawl, but a tornado, by God.

And then the ice is gone, leaving intensely blue waters, a blue that we'll never appreciate as much as we do now in its first cold blush, the sun playing on it like it never does in August, dazzling its millions of rays of light onto every inch of water starved for months under the ice that muted its life into a semi-darkness. If the moribund, patient lilies could smile in the sediments, knowing of their resurrection to come in July, the waters would be warm in a week. If fish could sing, the lakes would resound.

In April, birds begin appearing out of nowhere, their ancient brains having led them on another journey with their Moses. They are the truly faithful— pioneers every spring who travel to the landscapes where their ancestors have nested for thousands of years, making a

pilgrimage fueled by instincts far beyond our ken, instincts that guide them by magnetic fields, by the path of the sun, by the path of the stars, by river channels, mountain ridges, Lord knows what, but here they are, in our backyards, in our woods, singing to bring the world back to life. Every song sparrow carries more glory in its dawn voice than we'll ever know.

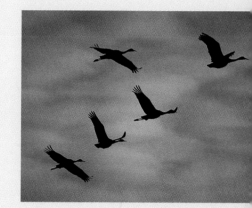

Oh yes, the songs speak of territories. There's biology, science, objectively observable behaviors going on, but why would we leave spring to the behaviorists, to the physicists, to the chemists, whose technical explanations offer only a pale beam of light compared to how the warm sun feels on your face? They will never be able to explain the smell of a south wind bringing the soil to life like a yeasted bread; how that languid, redolent, animate breath sets us right with the world. Spring throws the science books out with the snow, makes us all poets for a few weeks,

jumbles us up with emotions we can't articulate, can't explain, can't control. It's birth, and who will ever be able to explain that? How will we quantify the first chorus of spring peepers on the first warm evening of spring? Or measure the exuberance of wood frogs who have thawed from tiny ice cubes in the leaf litter into the most prodigiously sex-driven, inch-long, cold-blooded creatures imaginable?

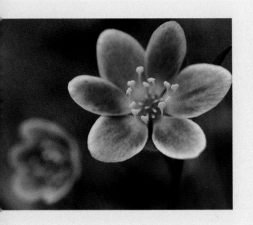

The flights of geese overhead, of tundra swans, of sandhill cranes, of whistling ducks winging at breakneck speeds—all carry the music of warm sun and the smell of rippling water. Red-winged blackbirds rim the marshes, their musical "oak-ka-lee" songs ringing with the consistency of a church bell over a town, calling you to come to the service, the church is open, God has arisen, if nowhere else than in our hearts. It's time to sit together, tell the long stories of

winter struggle, and revel in the warmth that blows from heavens and not from a basement furnace. *Revel* indeed. *Rebel. Reveal. Revolt.* Spring gives everything a chance to reawaken, if only we'll listen a while, sniff the air with the alertness of our dogs, breathe deep, deep, deep, and come alive.

Winter, the ultimate editor whose red lines mean more than death to words, has passed. Spring, the temptress, the changeling, the liar, has finally arrived. We're eating maple syrup so amber that the sun feels jealous. The snipe winnow from the heavens in the early morning, and the woodcock *peent* from the ground and jump into the air to dance at dusk. Fish spawn and eagles gluttonize from high pines, clutching fish after fish like they are picking blackberries heavy on canes, and soon it will be June, when summer arrives to push open the narrow window of spring into the heat of

mosquitoes and turtles laying eggs in warm sands.

It's a sumptuous feast for those who will sit at the table and dine. The marsh choir sings every morning; herons glide into their rookeries to feed ungainly chicks their regurgitated feast; osprey plummet into lakes and emerge with fish in talons to be torn apart in treetop nests; male songbirds sing of their vitality, some proclaiming from open perches, some warbling from woodland floors, some soloing while skulking in dense shrubbery, too shy to be seen on their own stage.

No southern bible-thumping preacher could possibly exult more about God than spring does. When we think of the light of God, we feel the spring. Spring shows us why we were put upon the Earth—to rapturously revel, and to quietly believe.

John Bates lives in Manitowish, Wisconsin. He's written five books on the natural history of the Northwoods, and contributed to two others. He also owns Trails North, a naturalist guide service.

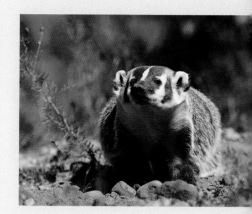

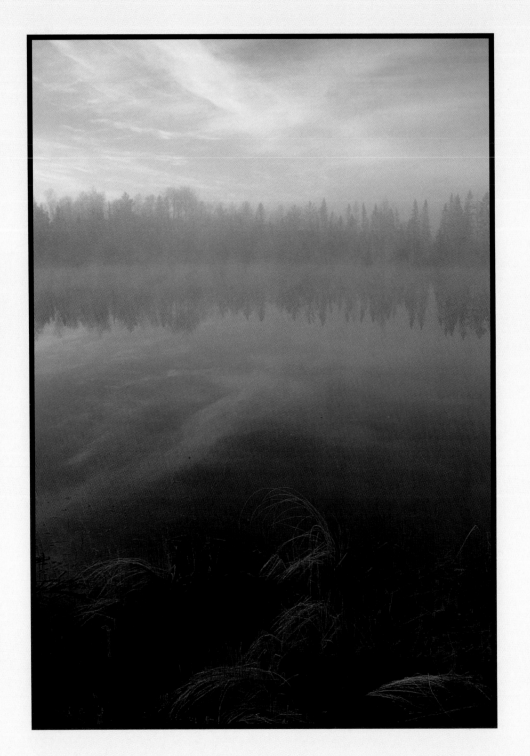

Left: Beautiful unfolding morning on a quiet Northwoods lake.

Right: Moonrise over Lake Superior; Isle Royale National Park.

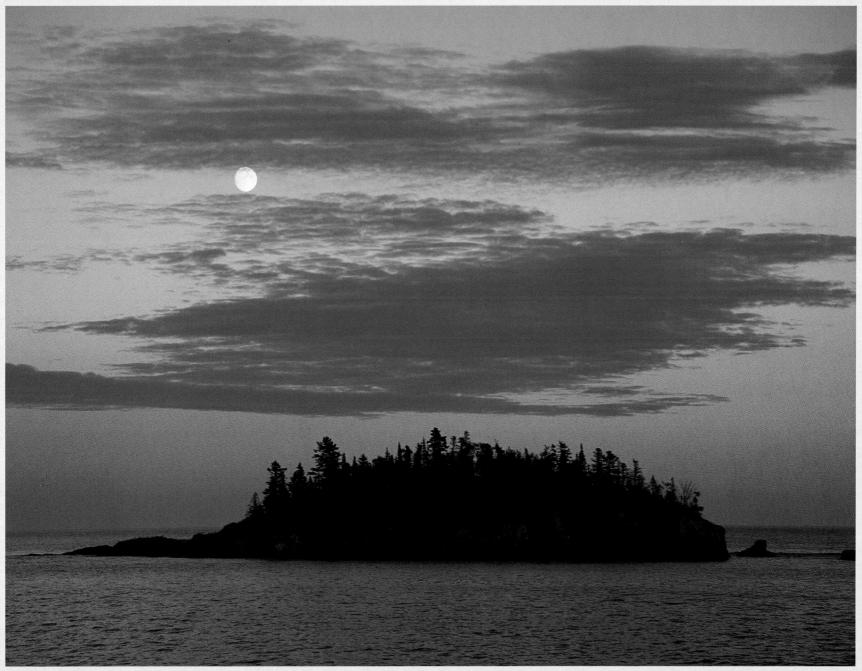

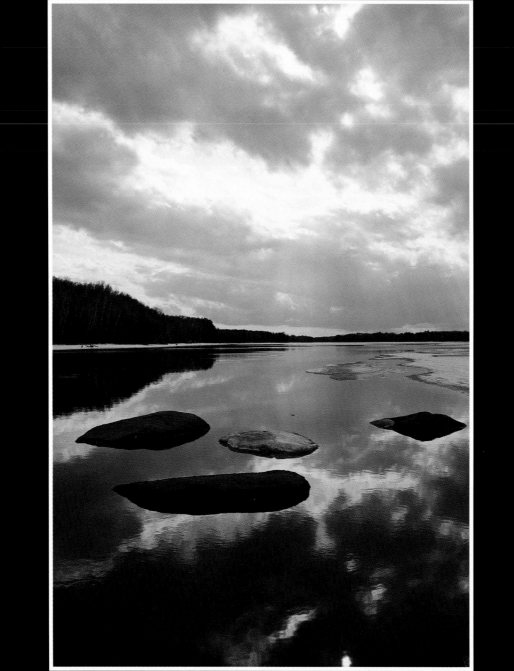

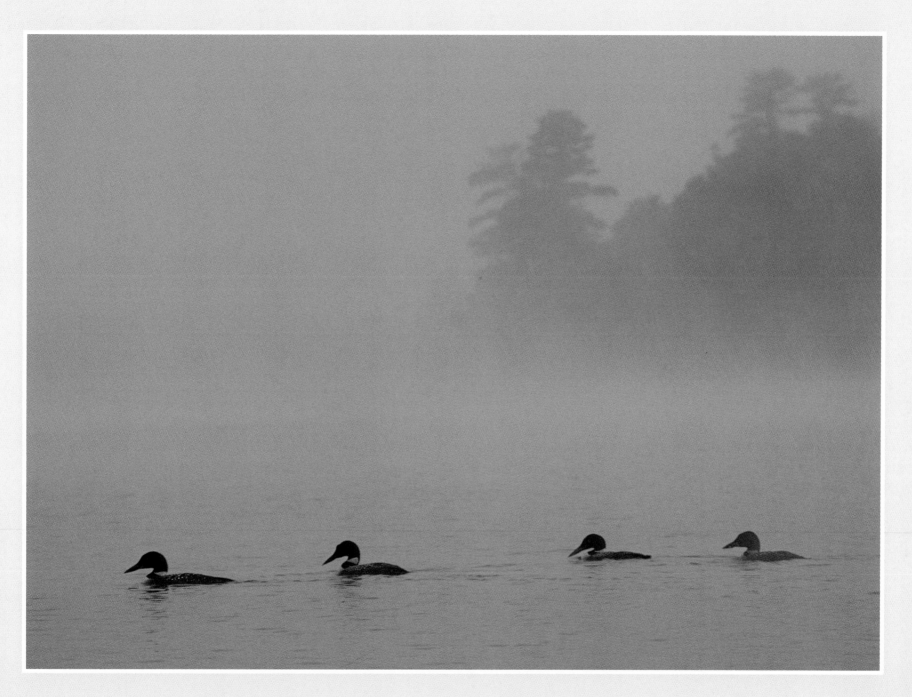

Mated loon pairs deciding who gets prime nesting island; Chippewa Flowage, Sawyer County, Wisconsin.

Left: Ice slowly losing its grip on Turtle-Flambeau Flowage; Iron County.

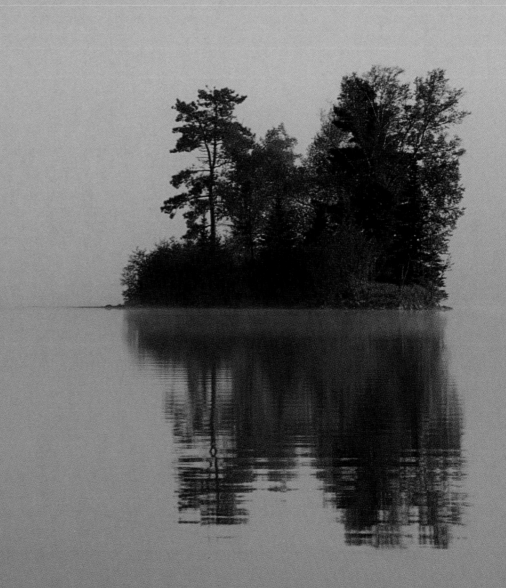

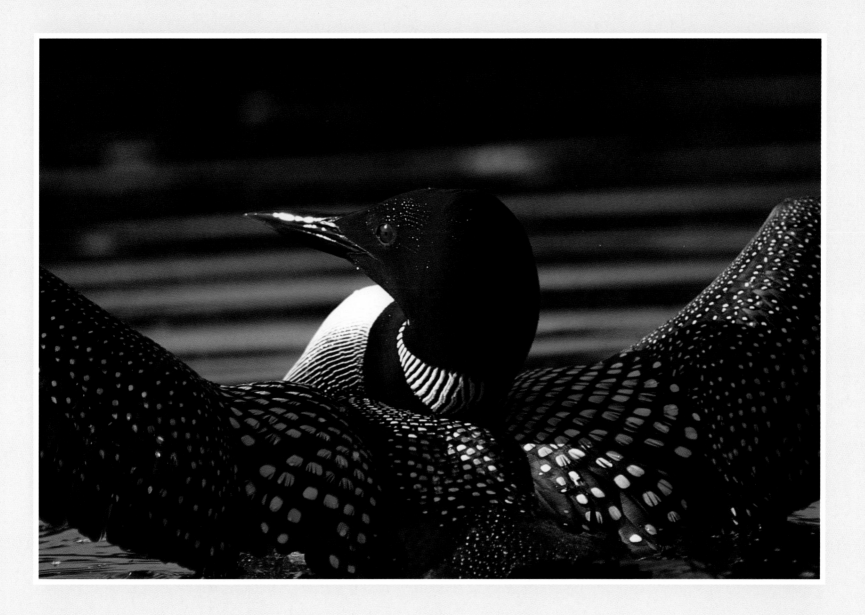

A loon stretches its wings.

Left: Anglers appear like a ghost ship out of the morning fog.

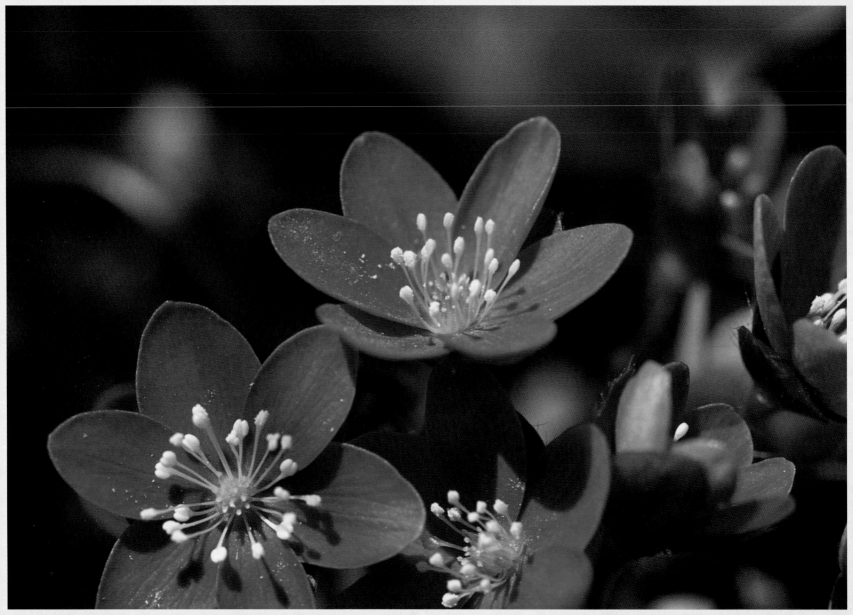

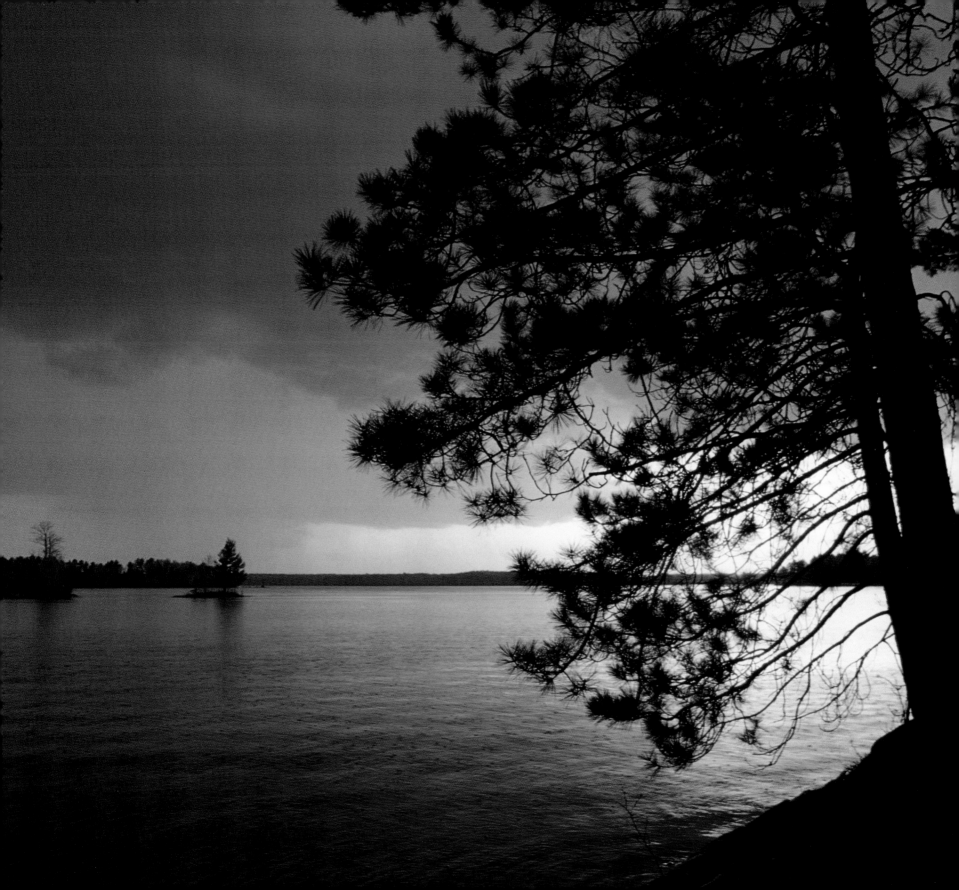

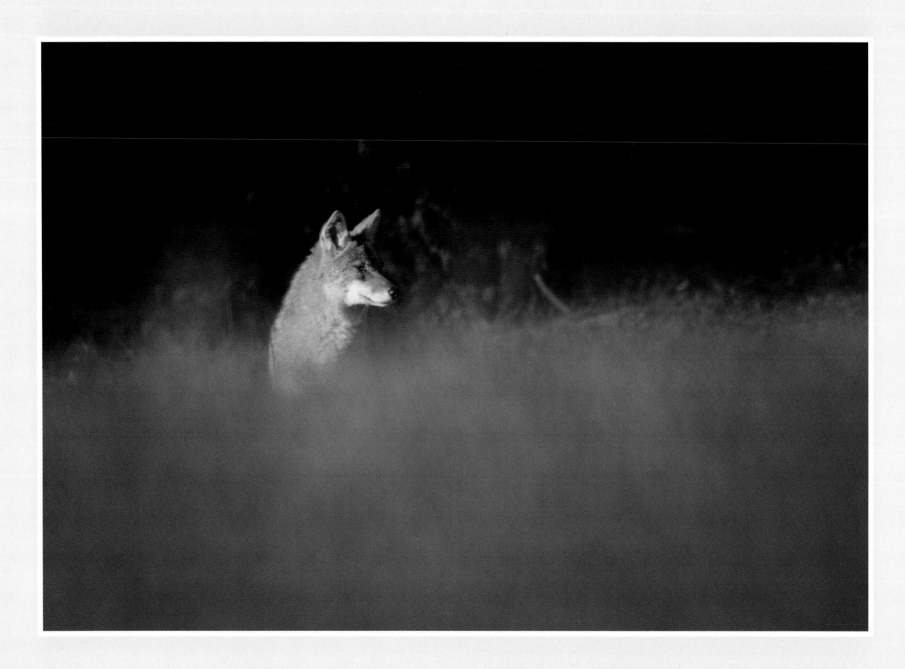

Coyote eases into a field edge, all senses attuned, on a morning hunt.
The coyote's habits have changed in recent years since losing "top dog" status to the wolf.

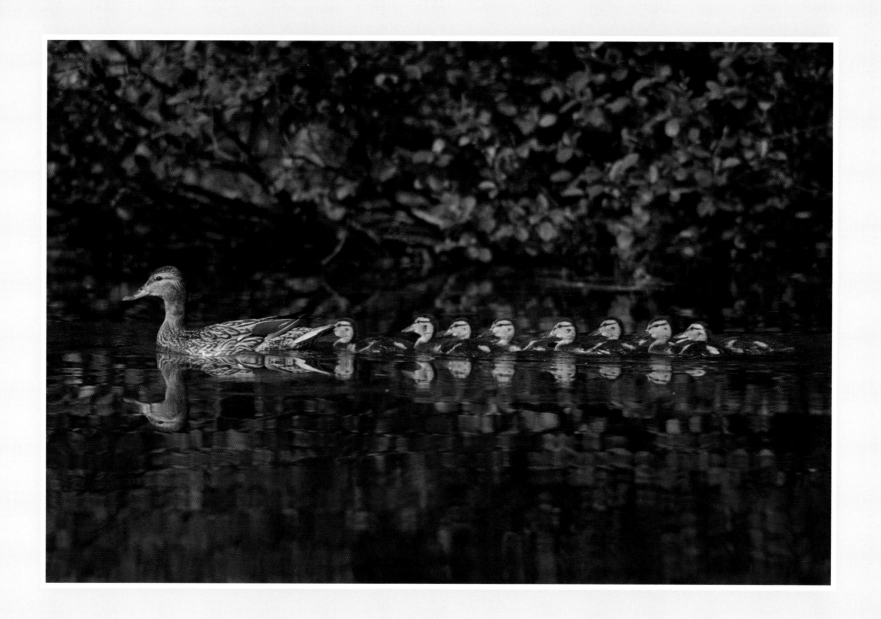

Mama mallard with her ducks in a row.
Allequash Lake, Vilas County.

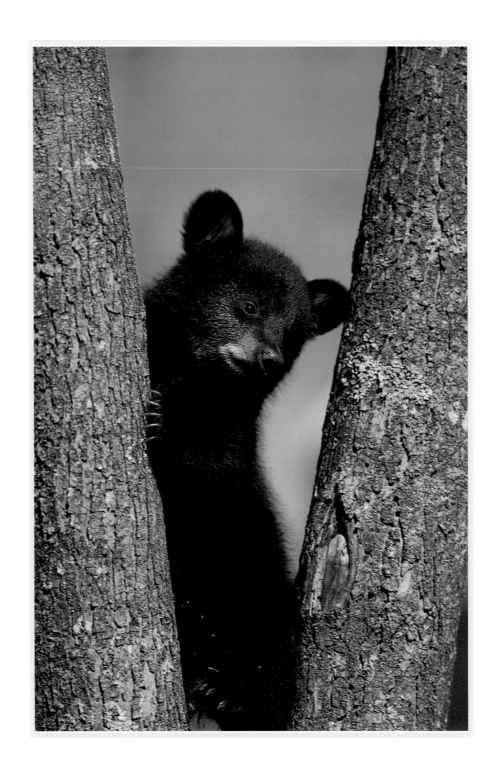

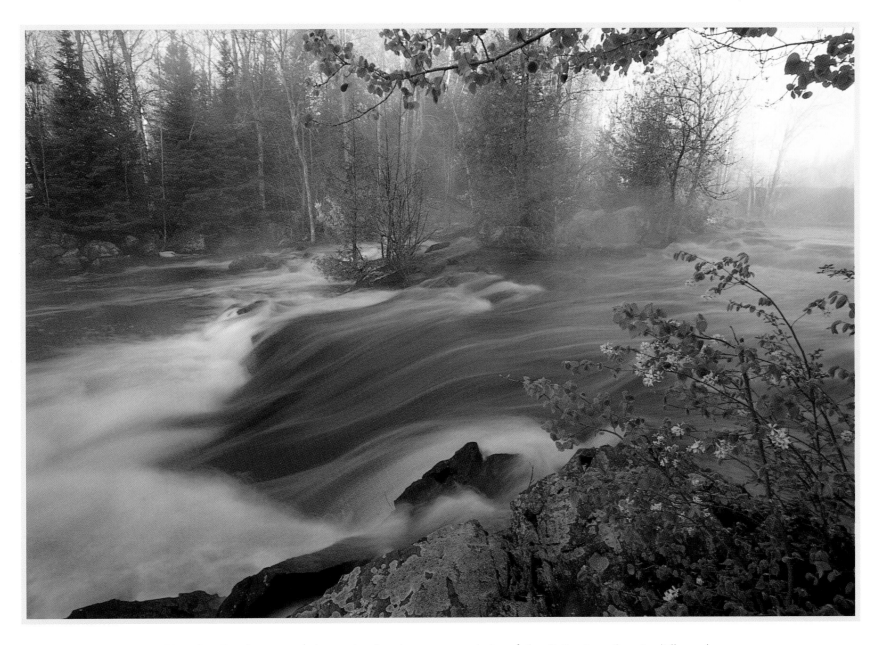

Blooming Juneberry and the rush of spring water at Lake of the Falls; Iron County, Wisconsin.

Left: Bear cubs learn at an early age to find safety by climbing a tree.

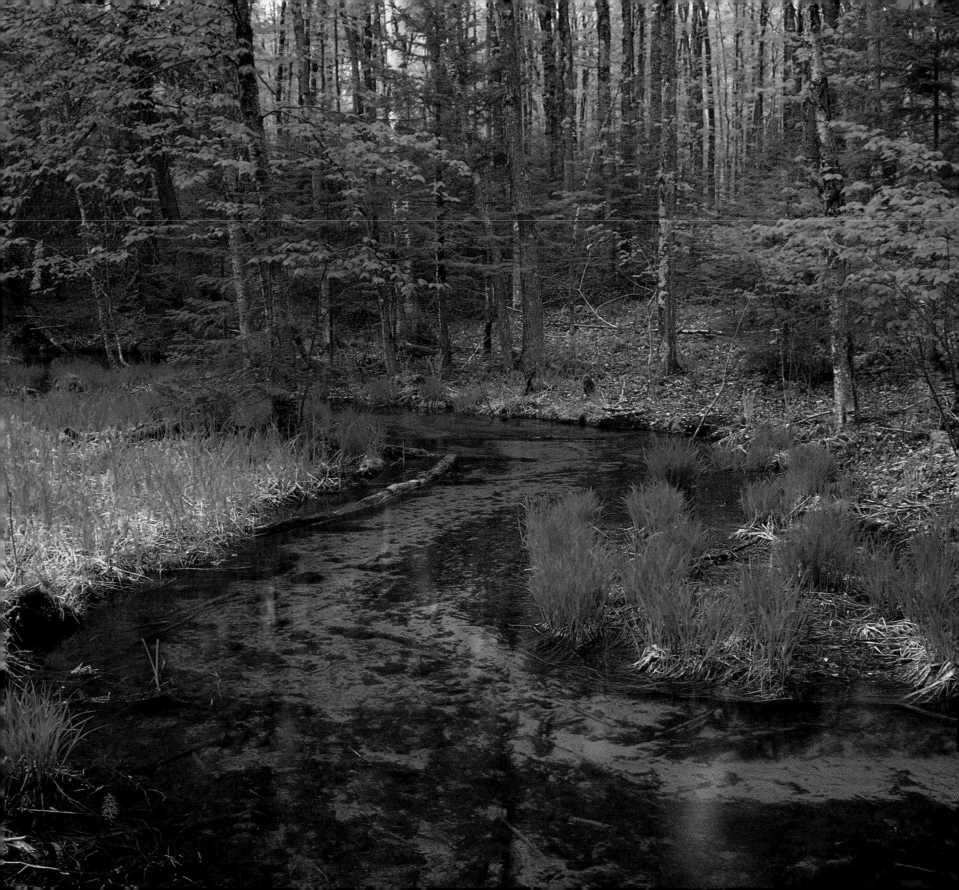

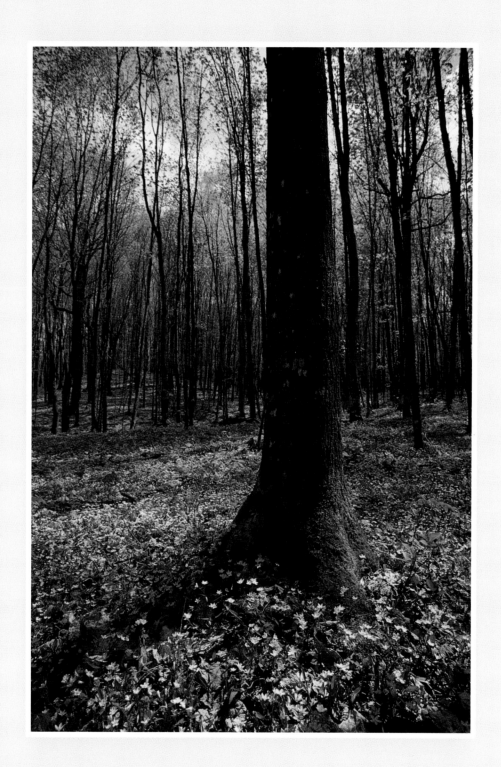

Left: Meandering brook in the
Catherine Wolter Nature Preserve.

Right: Forest floor carpeted with
Spring Beauty; Underwood
Natural Area, Iron County.

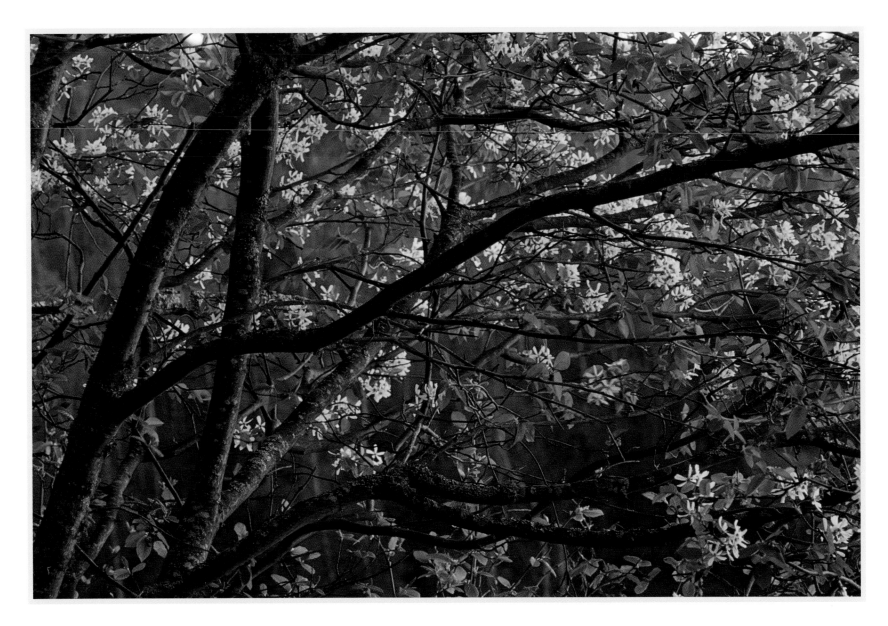

Is there anything more cheering and renewing than a bushful of fragrant spring blossoms?

Right: Male ruffed grouse, strutting his stuff in an attempt to attract a female.
Grouse have a unique habit of "drumming" during their spring mating ritual.

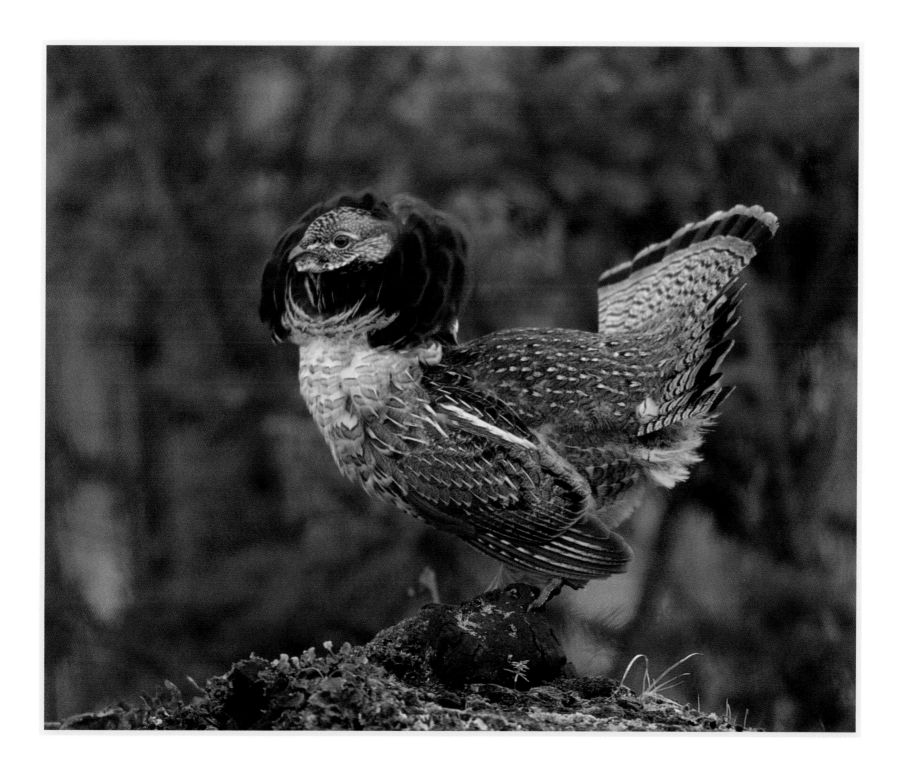

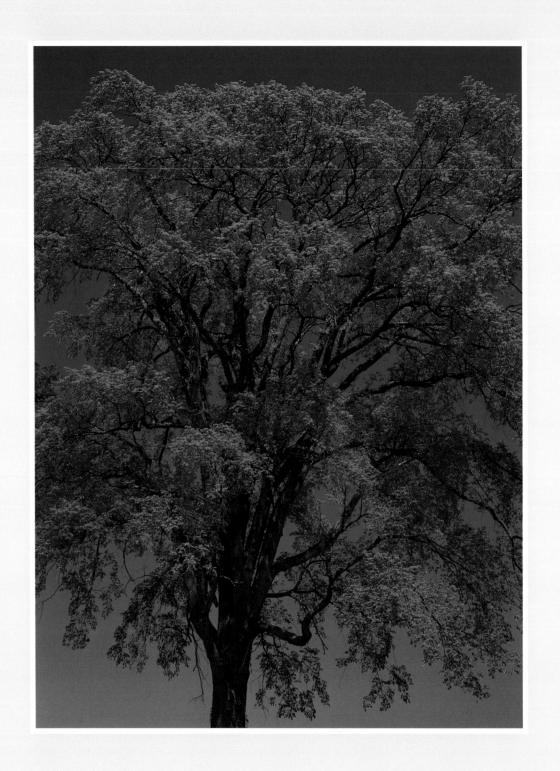

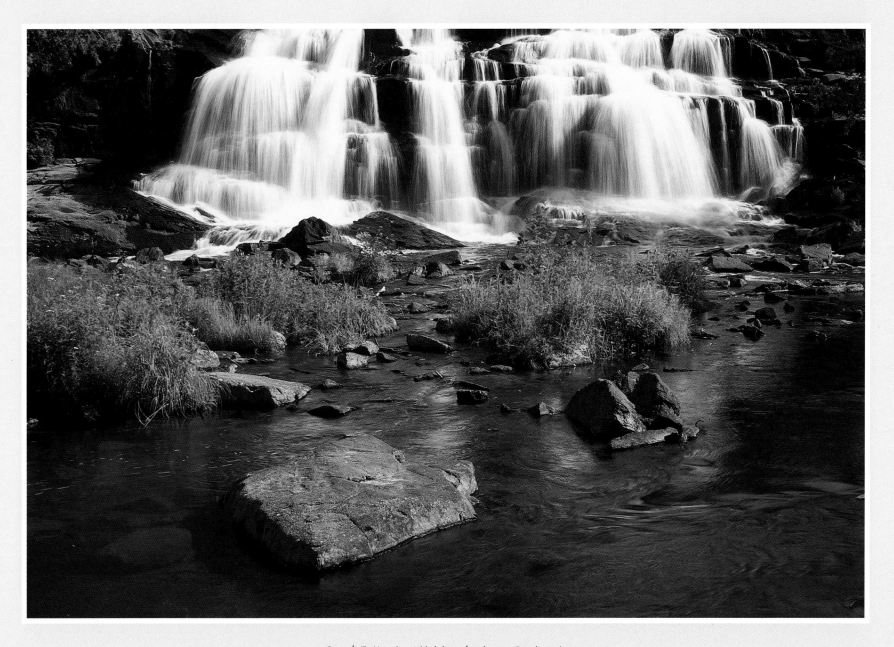

Bond Falls, in Michigan's Upper Peninsula

Left: A majestic elm bursts into vibrant green against an unblemished azure sky.

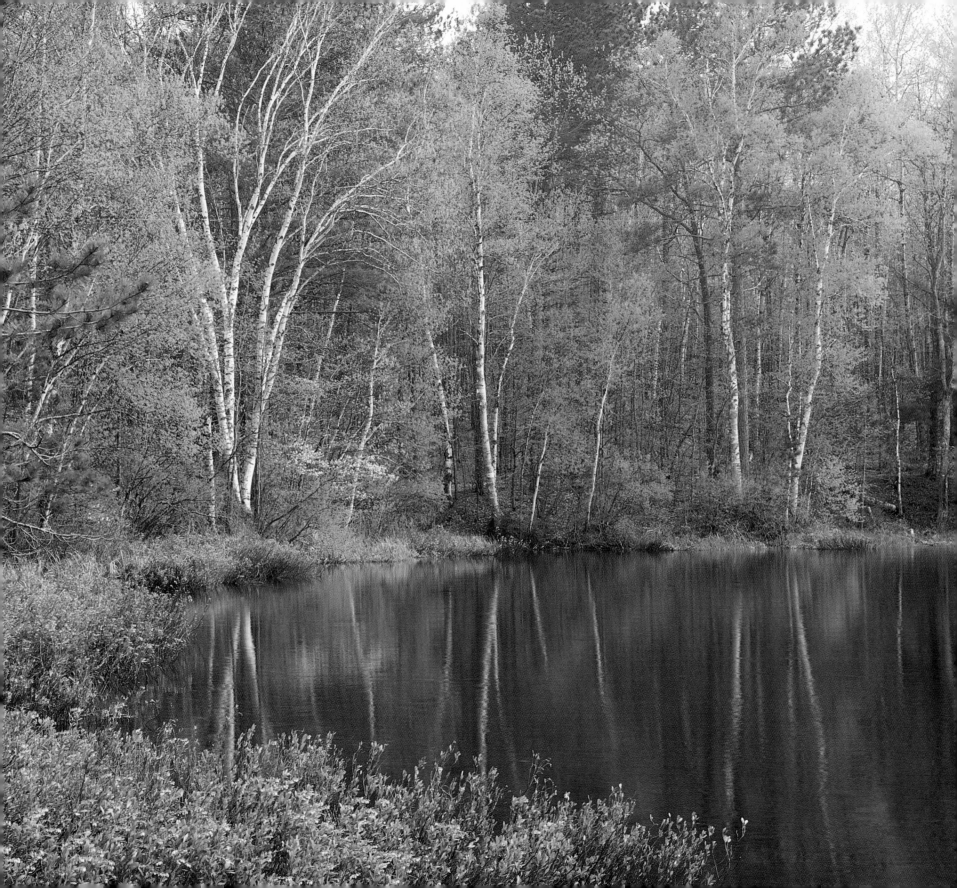

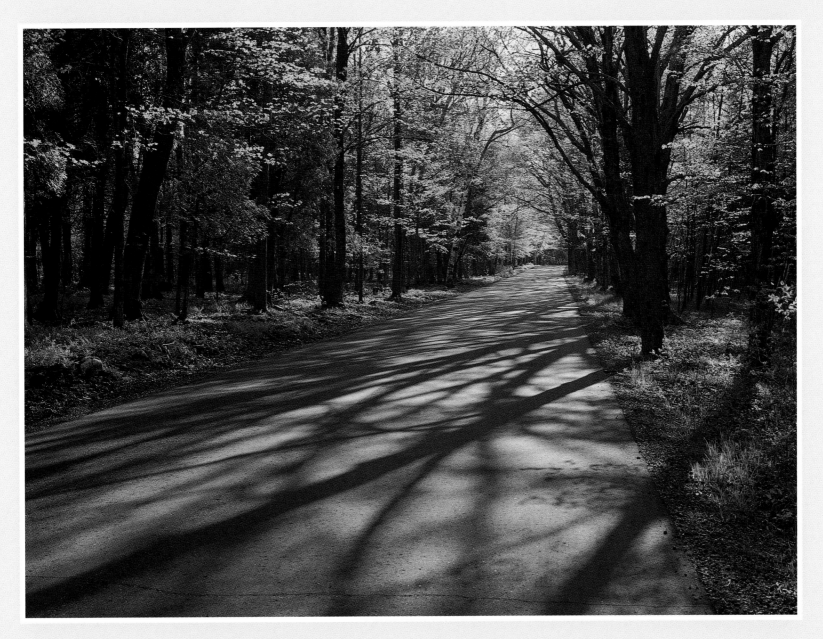

What's more soothing than walking, biking, or driving down a quiet forest road on the first warm spring evening? Peninsula State Park, Door County.

Left: Soft light on a still lakeshore; Chequamegon National Forest, Bayfield County.

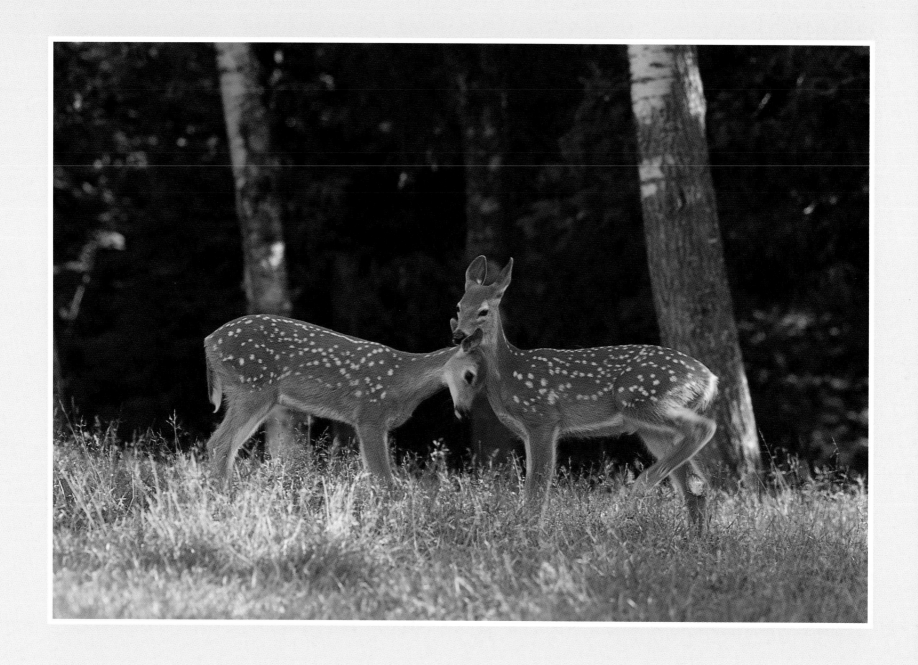

Somehow whitetail fawns find time for play despite the myriad of predators seeking their whereabouts. Fawns are generally born in late May.

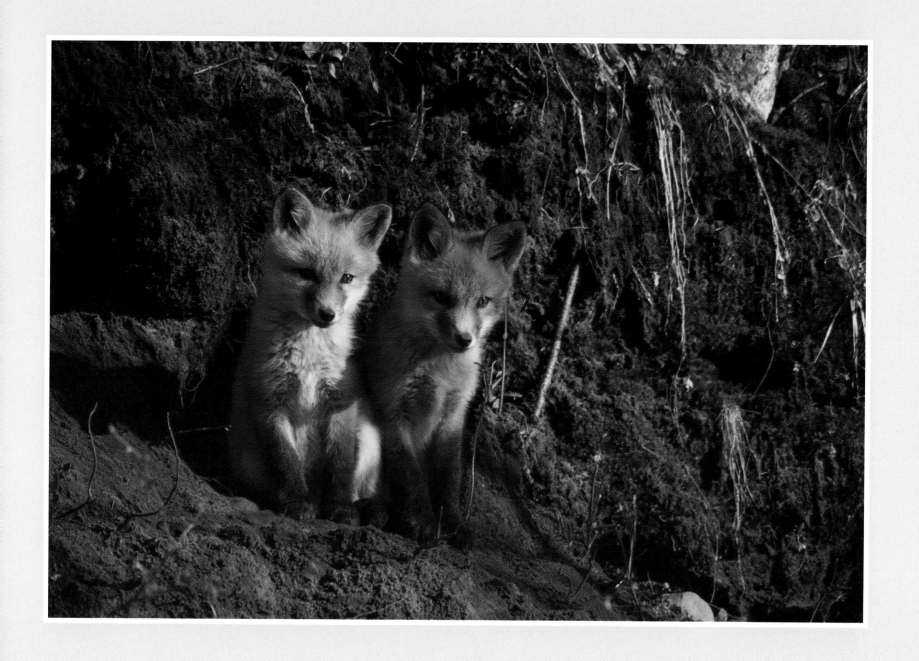

Few things are as entertaining as watching a litter of wild red fox pups
during the first few weeks after emerging from their den.

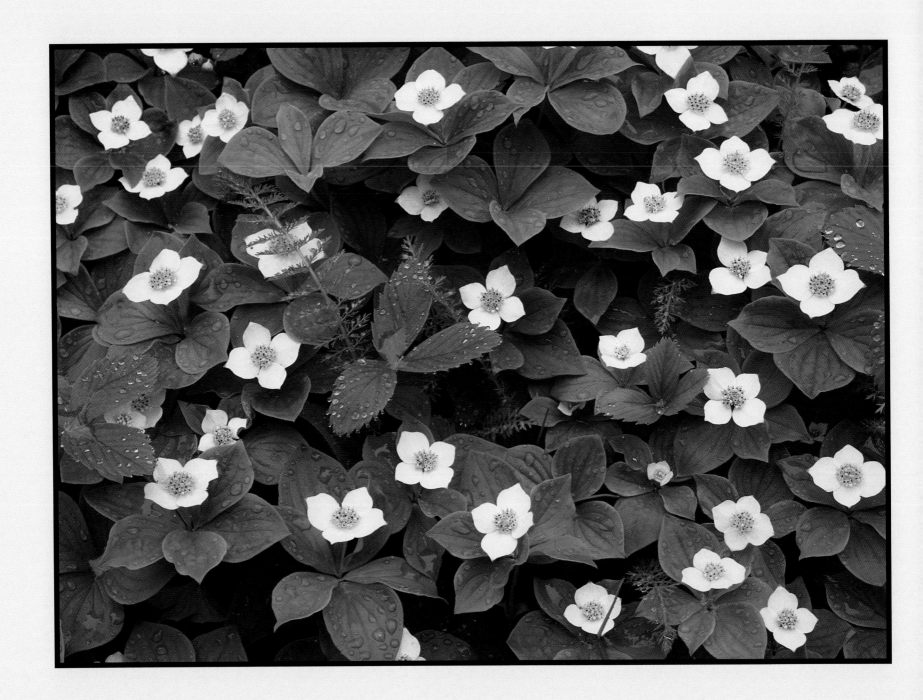

Bunchberry in bloom

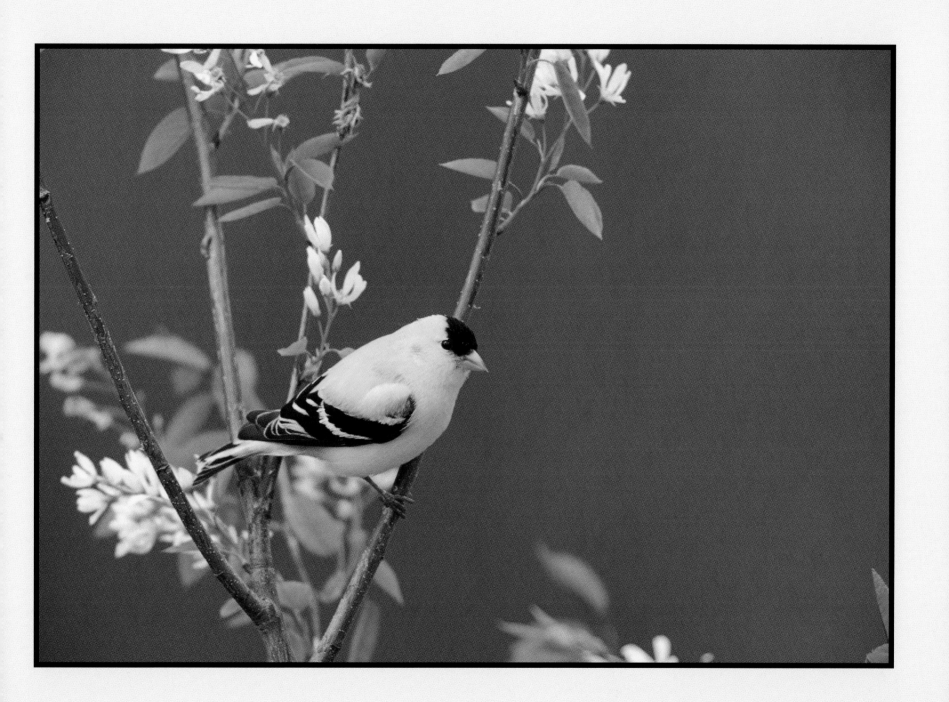

Male goldfinch

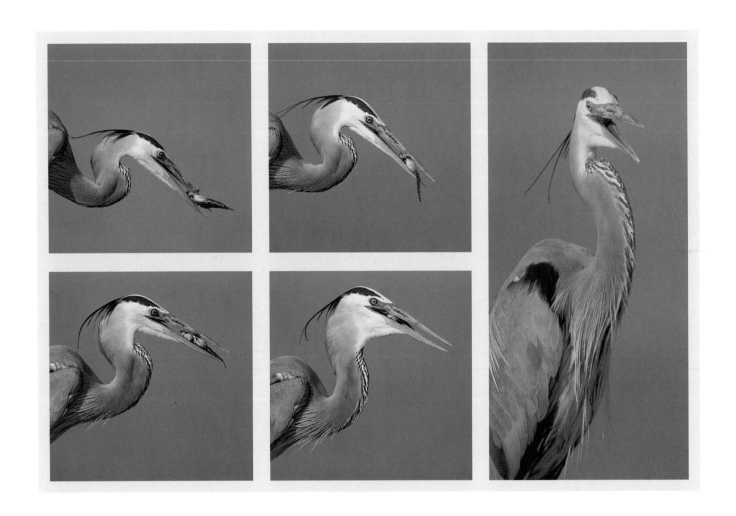

Great blue heron enjoying a mid-afternoon snack.
Herons commonly catch larger fish by spearing them with their large beaks.

Right: Oxbow Lake, Mercer, Wisconsin.

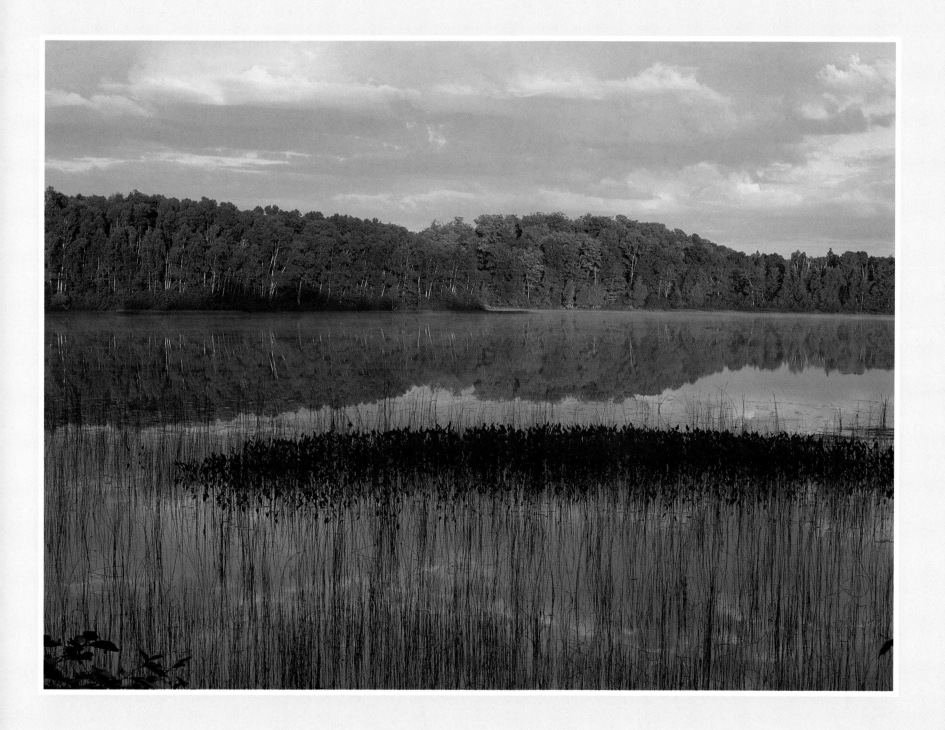

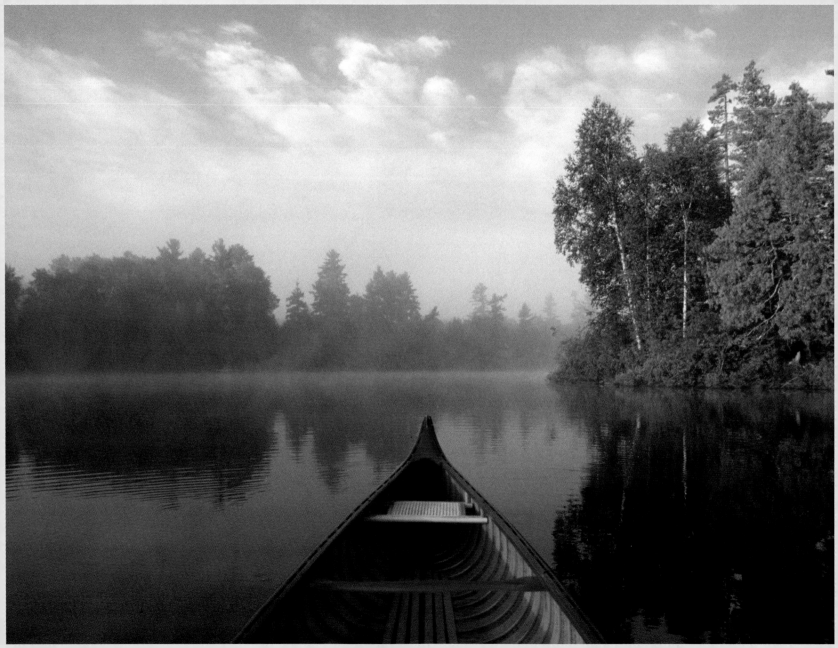

Summer

by Justin Isherwood

He was as crazy as I, and it was pictures as caused it— *Frances Ann Hopkins pictures, to be precise. She was an 1870s Canadian artist who painted the canoe brigades of the Hudson's Bay Company. It was those paintings that drove us nuts: "Bivouac," "Shooting the Rapids," "Lake Superior" . . . these what put us over the edge and turned two other-wise decent young husbands and fathers into* mangre de lard, carrior de bois, voyageurs. *I mean canoe nuts. He and I, we once did the Slough Gundy, supposedly suicidal—by comparison the Eau Claire Dells is only subhazardous—followed by a host of whimsical, cunning, and merely gorgeous rivers. I mean the Two Hearted, the Wolf, Little Wolf, Peshtigo, Prairie, Plover, Tomorrow, Namekagon, Temperance, Baptism, Montreal,*

Bois Brule. Name a river on the Wisconsin deck of the Laurentian and we pulled paddle on it. The Old Scab we called it—the granite breastplate that extends down into central Wisconsin, bruises the northeast corner of Minnesota, then like a kicked dog wanders north to lay down by Hudson's Bay. This is antediluvian granite. It mothered us, it mothered our waters. Old it was before Rocky Mountains were born, enough ancient to remember when continents were conjoined in a youthful glee called Gawanaland, a billion years previous, when life was yet single-celled and not a thing to bet good money on.

The Scab defined for Tom and I what was the north end of all things. The Scab was what made a river worth lashing an 18-foot aluminum canoe to a Volkswagen bug and meeting at some curious new water come Saturday night. We gave our wives one good reason to divorce us—a court document could easily name it. It was the canoe.

Not every summer Saturday night was so devoted, because that would have been both impossible and cruel. Besides, I had to irrigate potatoes. I had returned to the farm after the Nam thing, where I met Tom. We were medics—hospital orderlies, actually—bed pans, limb disposal, surgical laundry. The initial infection was all his fault. It was he who showed me, after supper, a print by Frances Ann Hopkins. One glance and I was abducted by that time warp powered by canoes. It was as if these historical paintings grabbed me by the Adam's apple and pulled me bodily into the time of the fur trade, when the heroes and demigods all carried paddles. Before I was married, I had a modest fling with Porsches and MGs—spritely, nimble cars. What transfigured me was the canoe. It was not only lithe and eager, it was stealthful. This vessel copied the soul. It was the communion cup, the baptism, and the transfiguration all in one convenient package, whether Old Town, Peterborough, Grumman, or Ouichita. Though quite contrary to Jules Verne, it wasn't the mechanics as made this time machine. Instead it followed Einstein—relativity made the time machine.

Sometimes Tom called, sometimes I called him. Wednesday night, no hello how are you, instead we spoke in code: "Town 26N, Range 13E, Section 14." Sometimes latitude and longitude coordinates, sometimes a compass bearing. "Hawkins, 32° North 10 miles." Approximate location, except our needle always tuned to water and the nearest river. We met on Saturday nights. Mostly we used my canoe. His was an Old Town whose ribs we had already cracked. My aluminum had a bullet-proof quality. It once came off the car at 65 mph—scratches is all it suffered.

I made the usual promise to be home by noon. That is how come they let us go, because we pretty much did get home by Sunday noon. As explains why we canoed at the first light, which in July at 45° north latitude is 4:10 a.m. Cow time, Tom called it. I don't know if it is the cow barn in me, but I have always preferred cow time. If you want to cut the crap of human overload, try the woods at 4 a.m., tend the waters at 4 a.m. It is pristine, deserted at 4 a.m.

Hawkins 32° North 10 miles was on the south fork of the Flambeau. The town road quits a quarter-mile from the river, then it's a logging trail. Tom had marked the turn in with a Leinie's. That was his signal; mine was the Blue Bullet. Hawkins 32° North 10 miles is proximity, but not accurate enough to prevent wandering around two hours looking for the campsite. Whoever picked the spot had to get there first and have a fire going—that was our rule—and set out a beer can. Amazing how well they show up after dark, standing upright as a totem pole at the side of a dirt road.

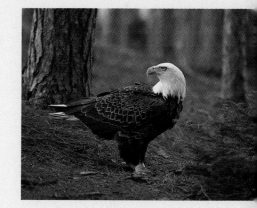

We didn't sleep in tents. After all, we were for one night voyageurs, *les guys*. A tipped-up canoe and a square of Fleet Farm hay wagon canvas was good enough. That's why the campfire was so vital, not only to find the campsite, but to inoculate ourselves against the mosquitoes. Nothing beats the adhesive smoke of pine branches. It sticks to your hair and teeth, and after a bit you're indistinguishable from the town dump. The hiking manuals recommend bug bomb. Voyageurs didn't use bug bomb, so if you want the time machine to really work, if you really want to turn time relative and

feel the earth and river the way it was, you gotta lose the bug bomb and the gator-aid. Wasn't just the river we were after, was the *time* of the river; not that we were re-enactors, but it doesn't take the shedding of many conveniences to restore a displaced version of a land too quickly spent.

The voyageurs went to paddle at first light and so did we; they slept under the canoe in their clothes, so did we—under canvas saturated with carbonized resins to fend off mosquitoes. Someday in a spare moment I think to begin a new religion based on the canoe and its message for the world. Its baptism shall be white pine smoke.

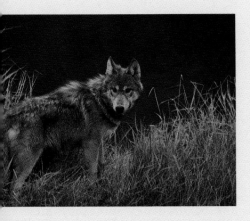

We always had supper together, Tom and I, no cheating on the way with a stop for burger and fries. The night of Hawkins 32° North 10 miles I was late, having to finish a round of irrigation before setting out, was 8 p.m. before I put the canoe on the car and Hawkins some 47 miles west of Tomahawk. I knew the spot 'cause I had once coded him nearly the same—Hawkins 32° North 11 miles, meaning the other side

of the South Fork. He meant a campsite on the south bank, easy enough, besides we knew the roads, at least the ones as led to rivers, and where to leave the cars before the trail gave out.

Was eleven before I got there, the trail marked as always by a Leinie's. It was still cold. A half-mile in I saw the fire, his car among some elderberry. I unbound the canoe and carried it toward the light, collecting tree trunks as I went. It had been a long farm week, typical July. Besides irrigating we were putting up hay and the knotter on the baler gave wicked trouble. Tom, hearing me, came and took the bow rope and led me through the trees. I felt like a cow.

A campfire, however meager, after the darkness of the woods always seems so bright. He went back for the pack on the passenger seat. I brought the food; I always brought the food. Tom was lousy at grub; good at canoes, good with a camera, lousy at food. I was the farmboy, I was raised by a farmhouse, I knew the ways of root cellar and canning jar, I knew food. Saturday night it was fried 'taters and thick-cut pork

chops. Sometimes it was new potatoes in a cheese sauce, sometimes fresh bread baked in a dutch oven, fresh bread and butter. The historical real guys ate peas and lard and anything else they could get their teeth around. Authentic voyageur re-enactment requires an early death. Tom and I weren't into true authenticity, just the divine elements. Smoke-cured, we were asleep soon after; I dreamed of hay balers.

Dawn is birds. By common assent we did not wear our watches, only in part because we promised to be home by noon. The other reason is the watch is the first and fundamental link to the consciousness of modern man. If you want to feel a river, if you want to feel the gravitation of waters, you gotta lose the watch. As a result it wasn't 4 a.m., it was bird time— chickadee, cardinal, white throat, rose-breasted, the little grunts of nuthatches followed by later-rising indigo buntings. Like proper voyageurs we broke camp and went—no preliminaries, no shaving, no coffee, tea, just poke the bow and go.

To be honest, we didn't talk all that much. Canoeing is likened to trout fishing; it is not talkative. Once we decided in a fit of fancifulness to speak only in French, or at least what we imagined as *Quebeçois*— the nice thing is, canoemen don't need that many words, most of which we already knew, the same words said on these waters for 300 years—*portage, degrade, avant, gauche, droit, dejeuner.* Tom could skip breakfast. I couldn't, as much as I needed waters tumbled over the wounds of old Laurentian land, as much as I was suspended while watching a red-tailed or eagle over the river in searching predatory circles, as much as I loved to dive for the cleavage between river rocks and emerge the other side in one buoyant piece. Much as that, I loved morning on the shore armed with a long-handled frying pan, eggs and ham. This the champagne hour, the air still and cold though it is July. Our breath visible, the smell of the night yet undistilled by the rising sun, mosquitoes not particularly interested, haze lingering in the shadows. Three eggs each over easy, the ham slightly burned. Beyond on the far

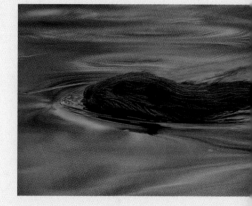

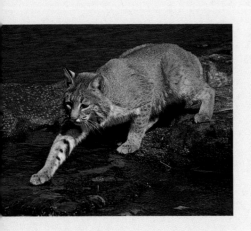

bank the unfurled flag of a white pine. White pine always strike me as having an oriental pose—that distinctive bonsai asymmetry. How often when I went downstate to Illinois where my sister lives, on returning home I looked for them as the first sign of north. I realize paper mills work just as well as markers, for they obey the scripture of the Laurentian Shield, needing terrible waters to power the pulper. The barns of my fathers are all born of that tree, the farmhouse where I was born was sheathed in it, and now its boughs cook breakfast . . . sorry . . . *dejeuner.*

A month or two would pass before we again exchanged another code, latitude 900 45° West, longitude 450 20' North, Grandfather Falls at New Wood, take Tug Lake Road.

The canoe phase of our lives lasted not quite forever. I still build the occasional canoe, still prefer morning when the woods and river belong to me and my long-handled frying pan. Nothing speaks the worth of the north better than this vintage light, the air cold, the white pine muttering oaths and

spells to hold it all still. *900 30° West; 440 25° North.* On my farm pickup is a ladder rack to service pivot irrigation that thrives on an aquifer held in place by the subducted Laurentian. As you might guess, a canoe fits rather nicely in the ladder rack. Precisely, in fact. *Adieu.*

Justin Isherwood is a farmer in the fabled Sands favored by the ancient waters. His book Farm West of Mars *won the first Wisconsin Ideas Foundation Award. It has been followed by* Book of Plough *and* Christmas Stones and the Story Chair. *He has written for* The Wall Street Journal, Newsday, National Wildlife, In-Fisherman, *and others. Now seven generations in Wisconsin, still farming on the same place north of the Buena Vista Marsh, whose cold, trouted waters move west. Justin has one wife, two kids, and one grandkid. The nephews come up from Chicago for a round of "golf" with their uncle, .22-caliber iron sights only.*

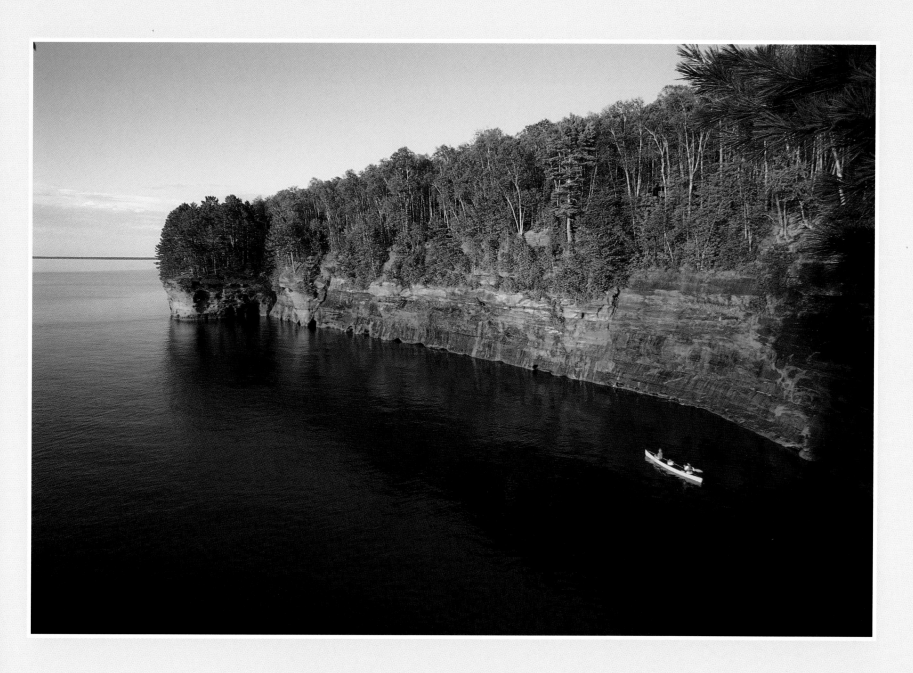

Family out for an evening paddle while on vacation.
Apostle Islands National Lakeshore; Cornucopia, Wisconsin.

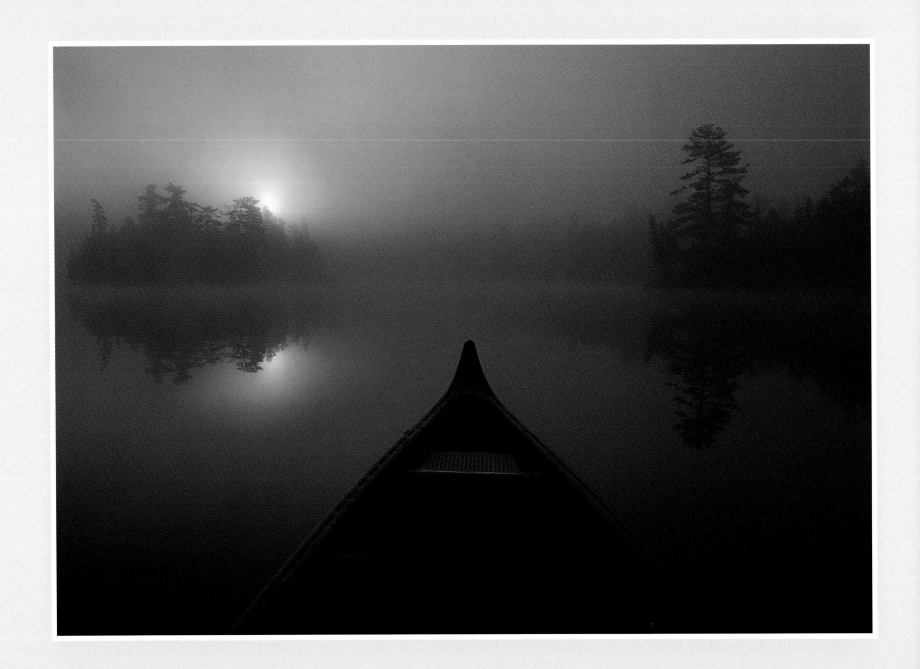

The North is a paddler's paradise.

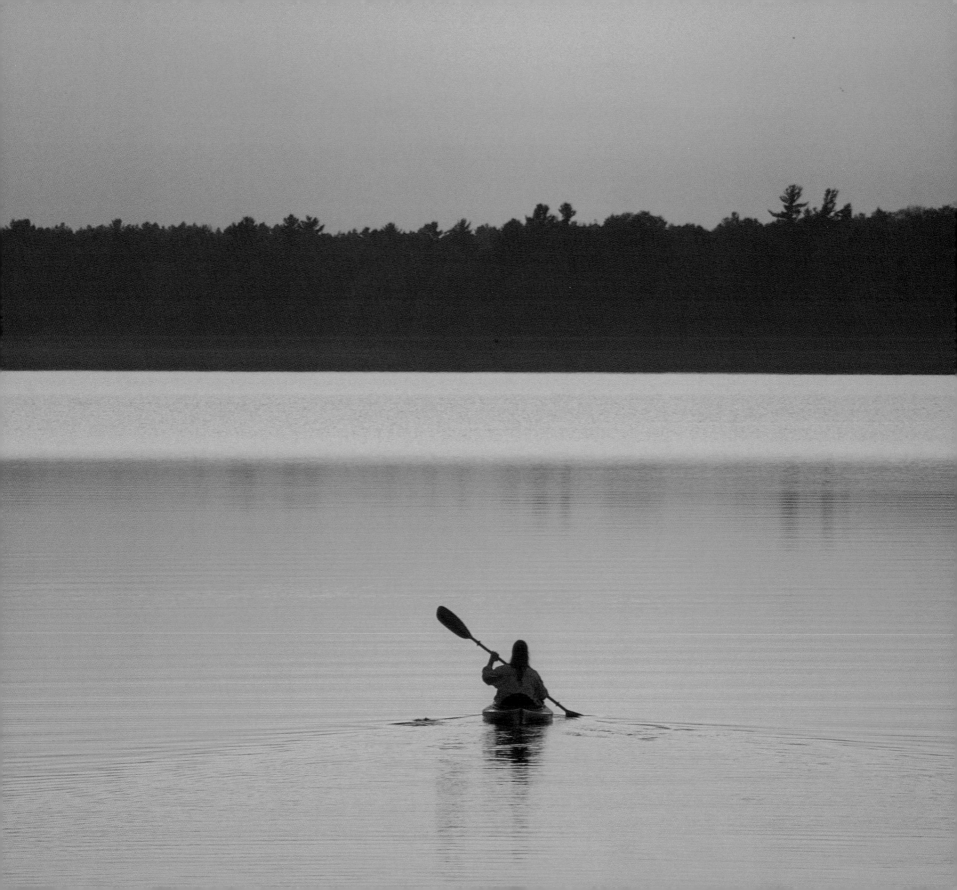

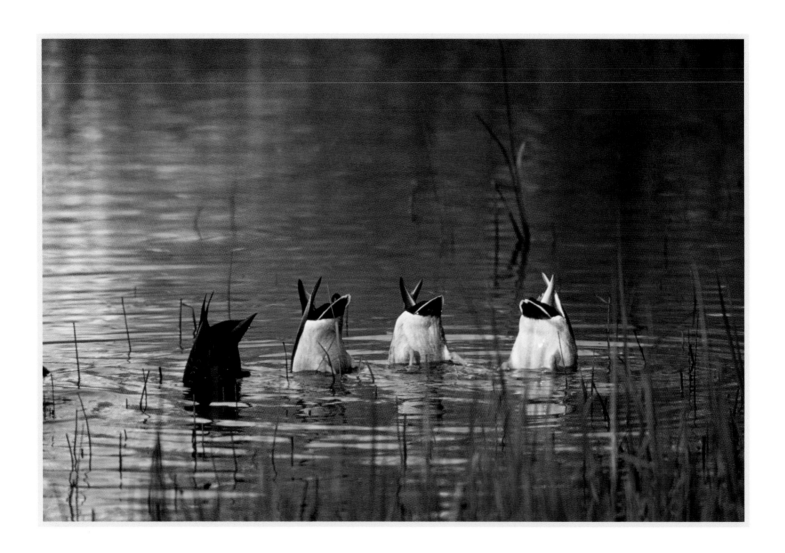

"Bottoms up!"

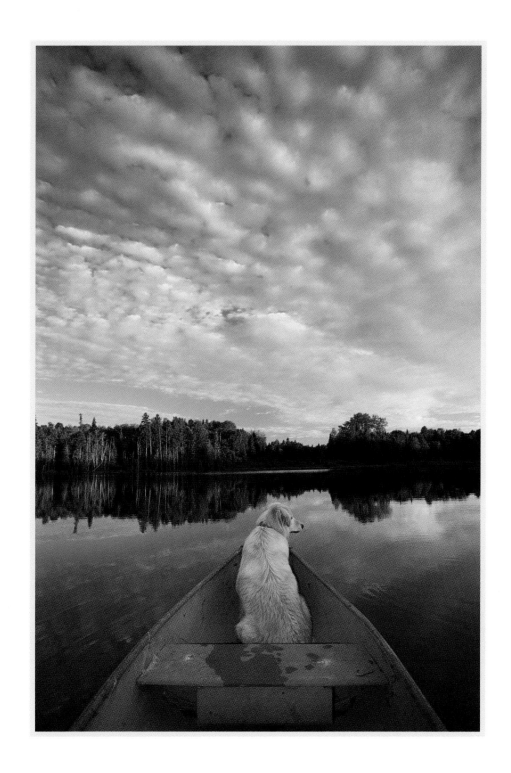

"Navigator"

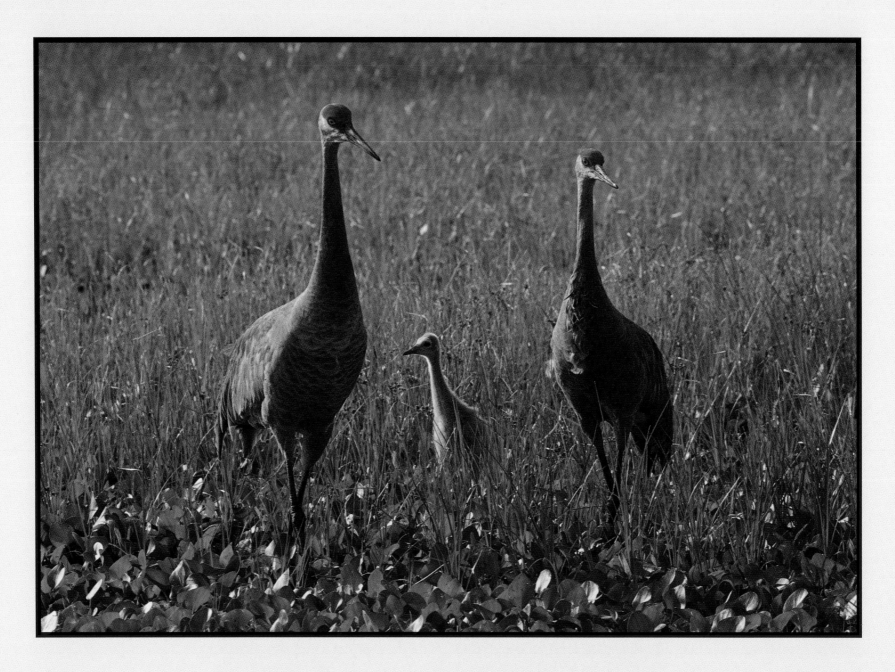

Sandhill cranes are becoming more common throughout the North.
Their clattery call is one of my favorite bird sounds; Crex Meadows Wildlife Area, Burnett County, Wisconsin.

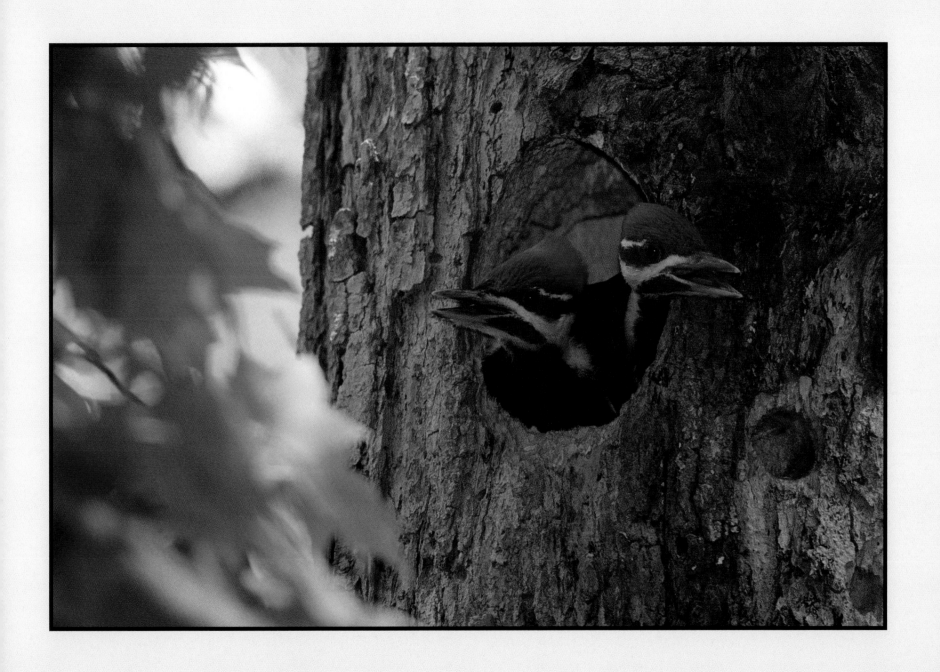

Pileated woodpeckers have long been a species of the Northwoods. Here are two young that were just days from leaving their nest cavity; Iron County, Wisconsin.

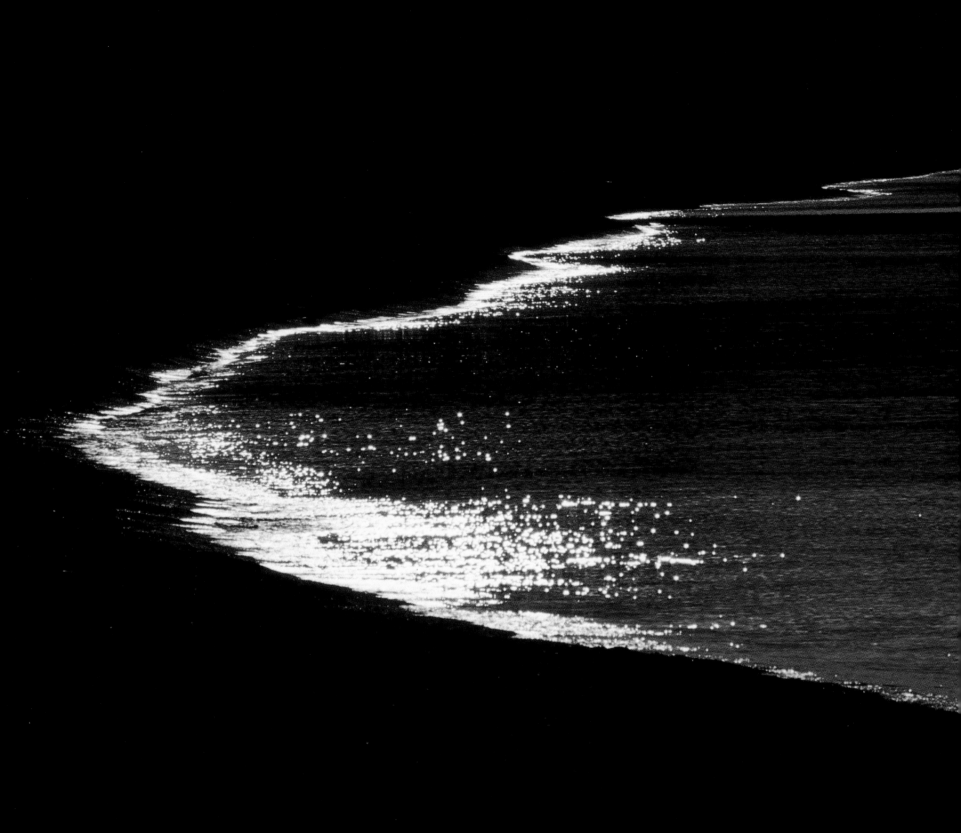

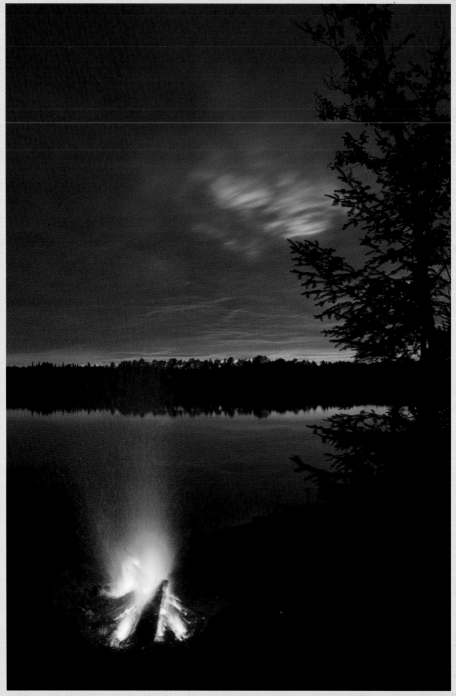

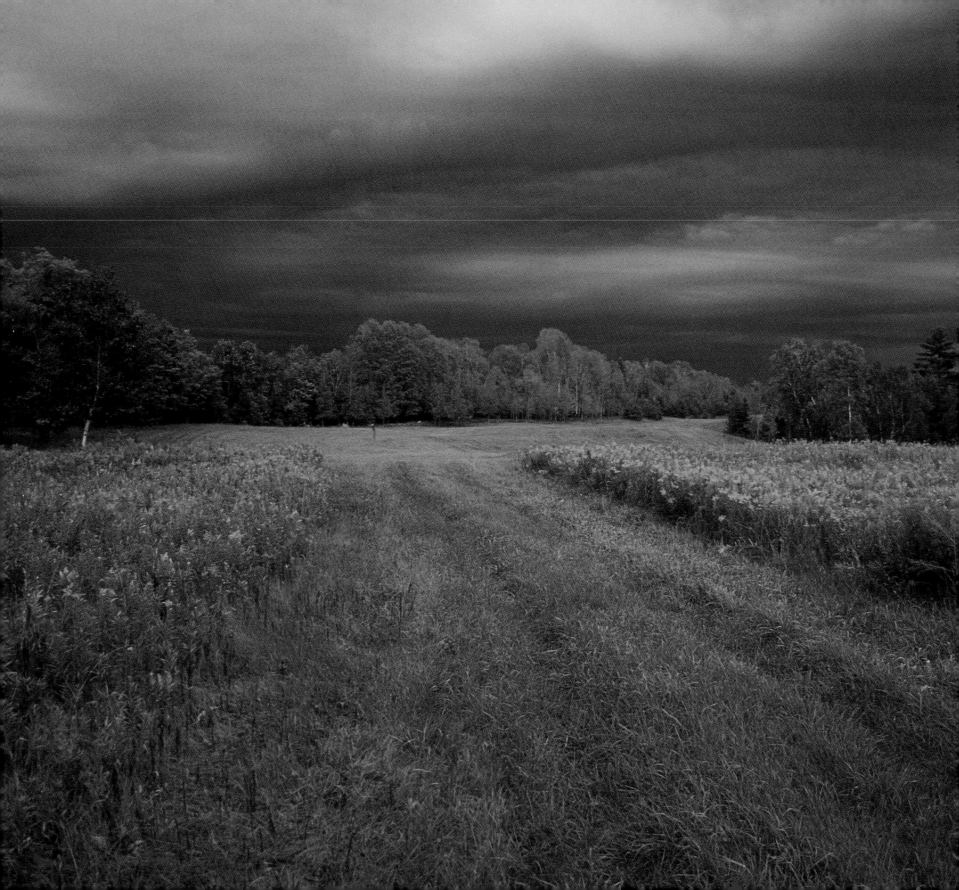

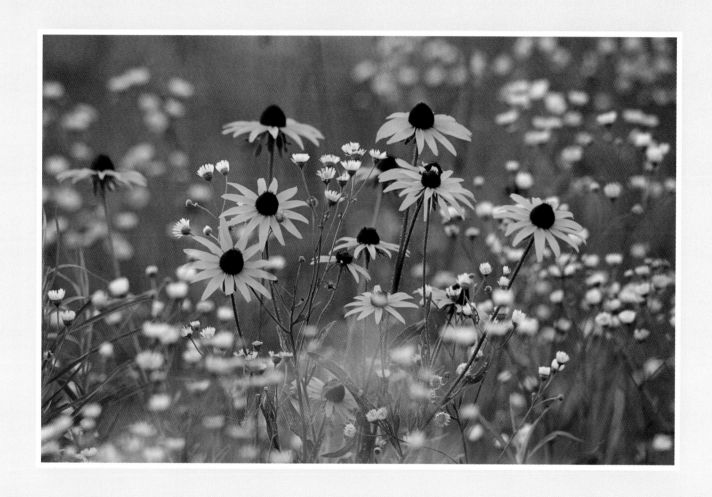

Many of the old farm fields in the North now produce wildflowers rather than a crop.

Left: Easily the most eerie, ominous and unusual light I've ever photographed—right out our back door.

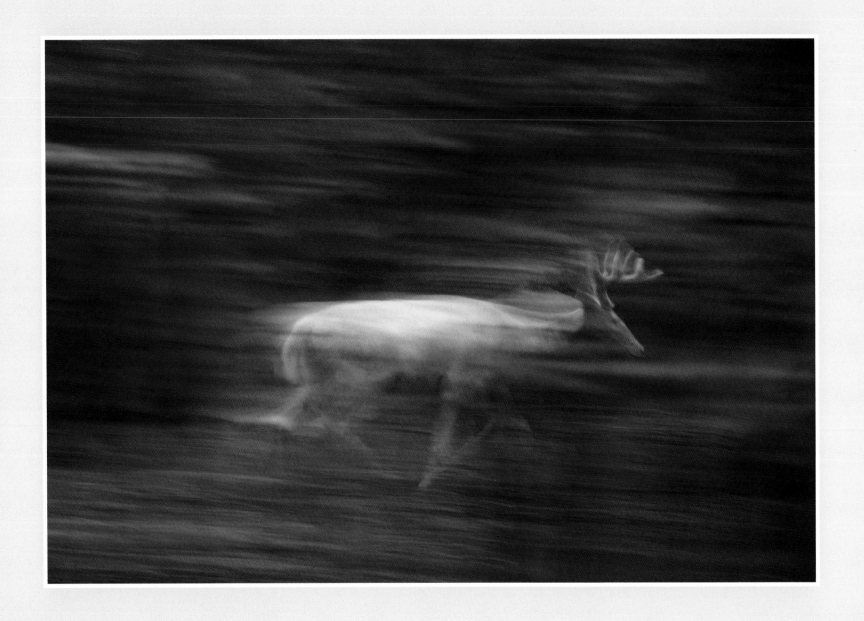

I've spent thousands of hours over a three- to four-year period pursuing albino deer. My efforts resulted in thousands of images. These deer are among the most visually startling animals I've encountered.

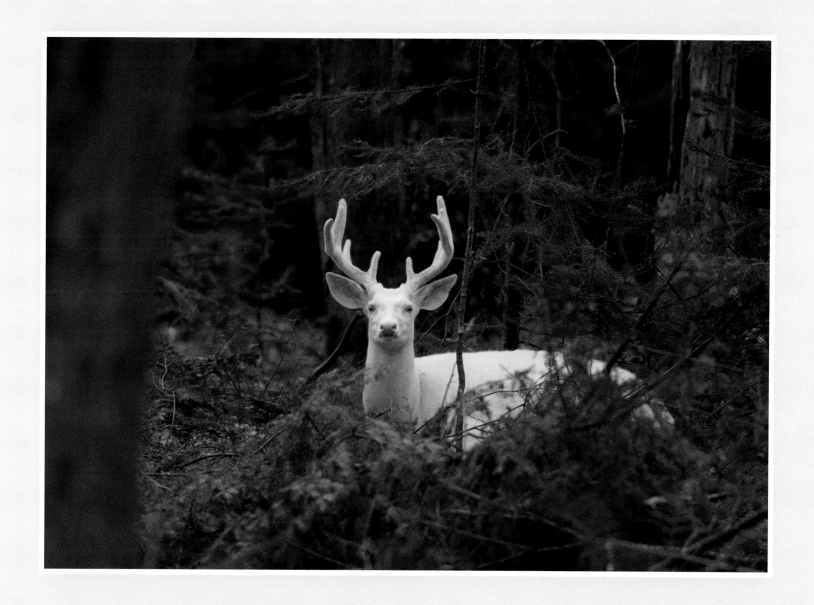

There are, to my best guess, about 100–200 albino deer scattered through the Northwoods, but virtually no research data on them. I've seen or gotten reports of sightings from Marquette, Michigan, to areas west of Ashland, Wisconsin.

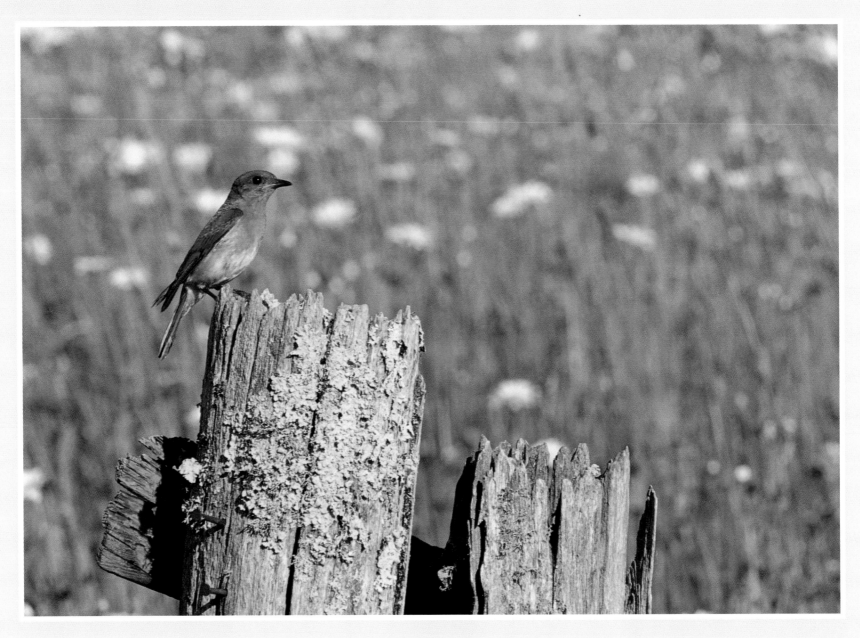

Male bluebird perched on an old, hollow cedar fencepost, a favored nesting site for the species.

Right: Swallowtail on orange hawkweed.

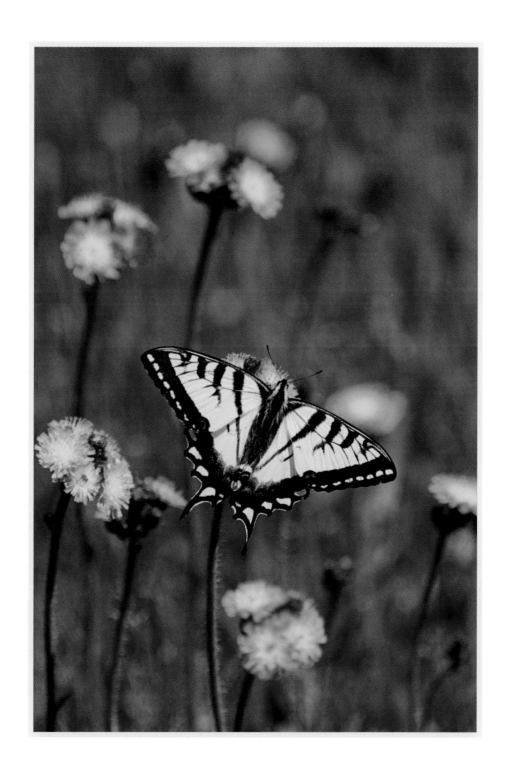

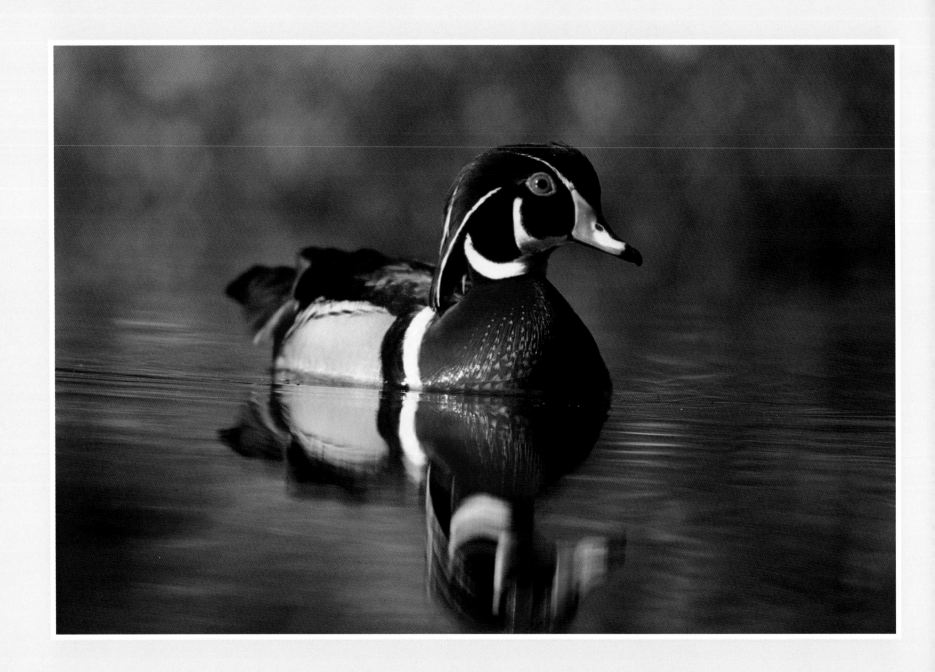

Wood duck drake; Right: Male fisher

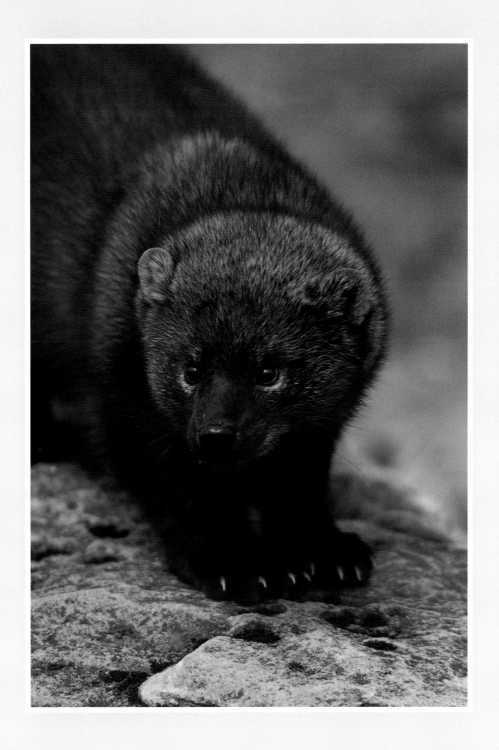

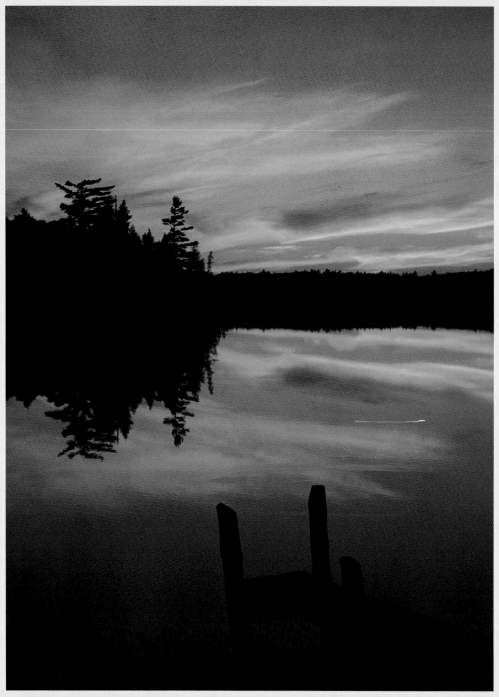

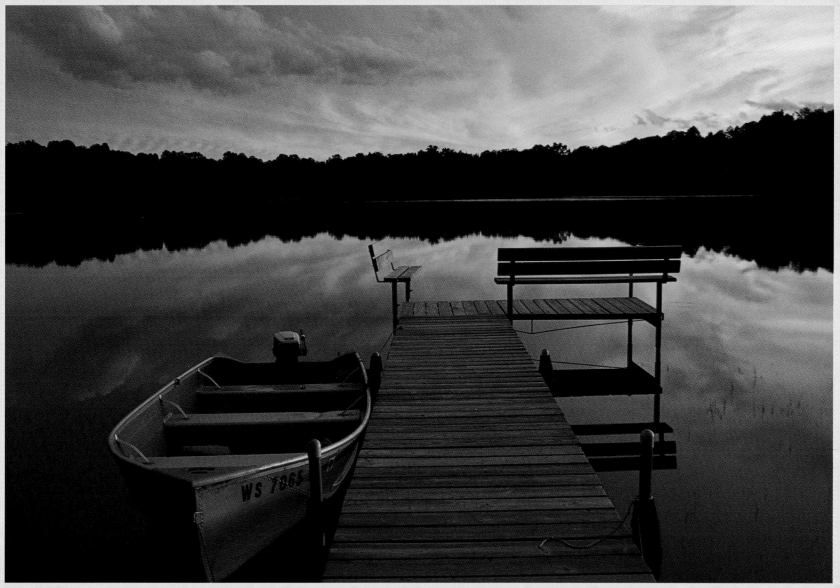

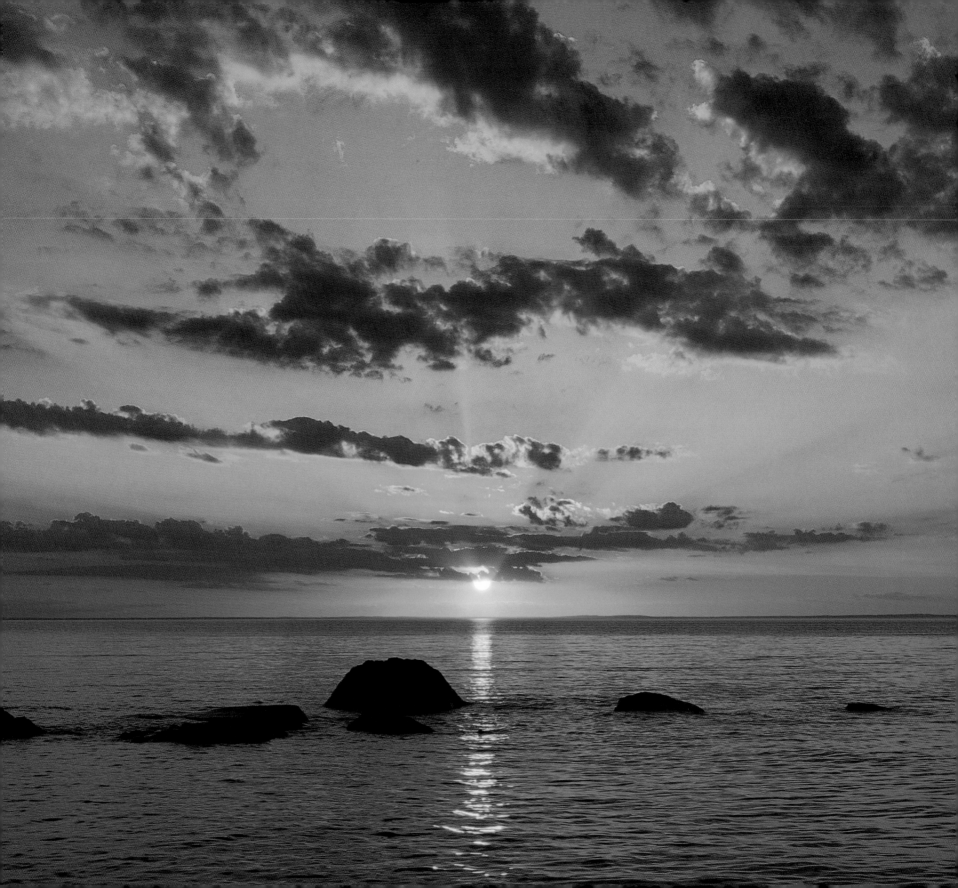

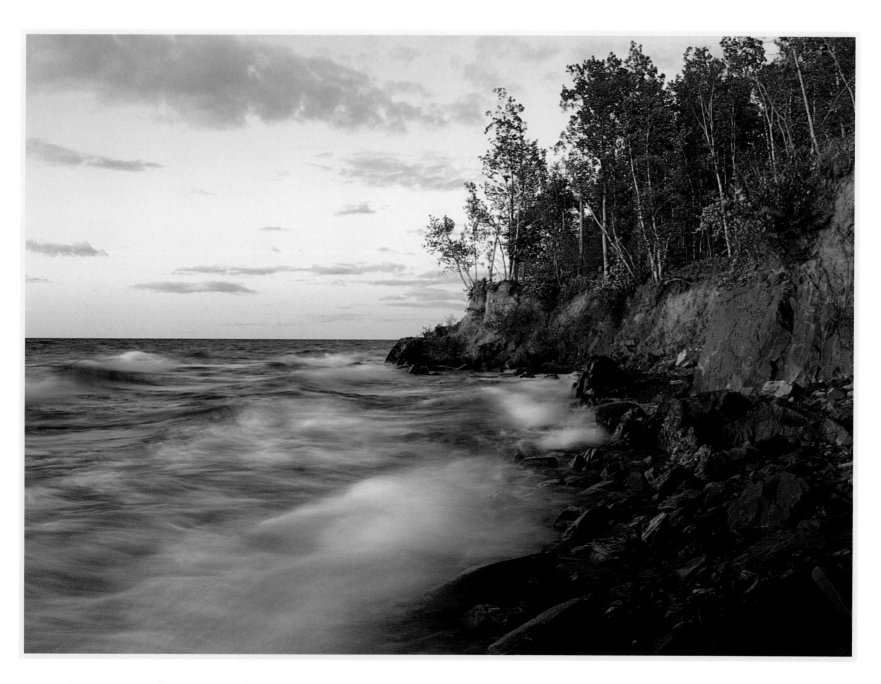

The vastness and uninterrupted horizons of Lake Superior appear as an inland ocean. Above: Little Girls Point, Upper Michigan.

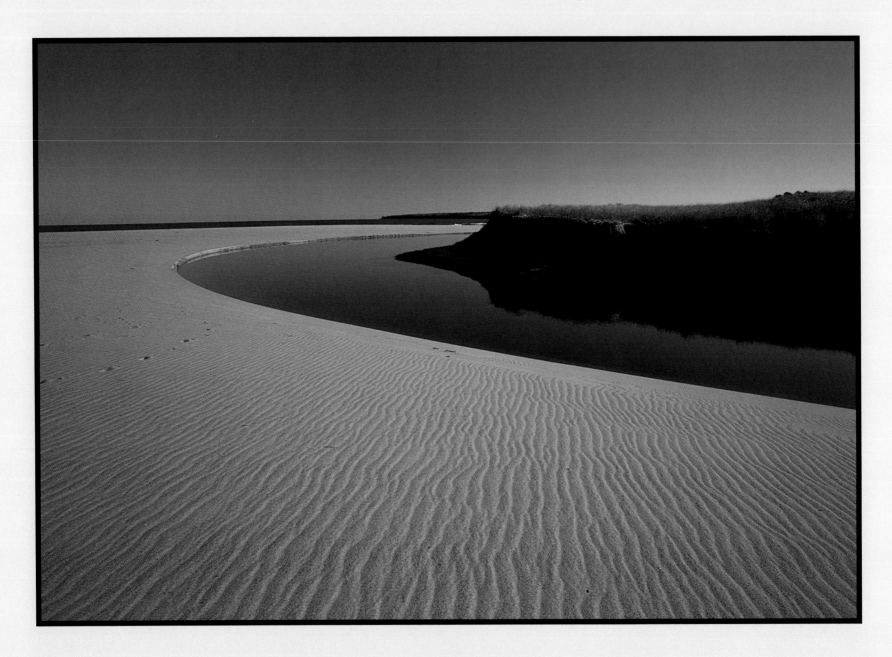

Wind-sculpted sand at the mouth of the Au Train River, Upper Michigan

Right: Idyllic summer day at Chequamegon Bay on Lake Superior.

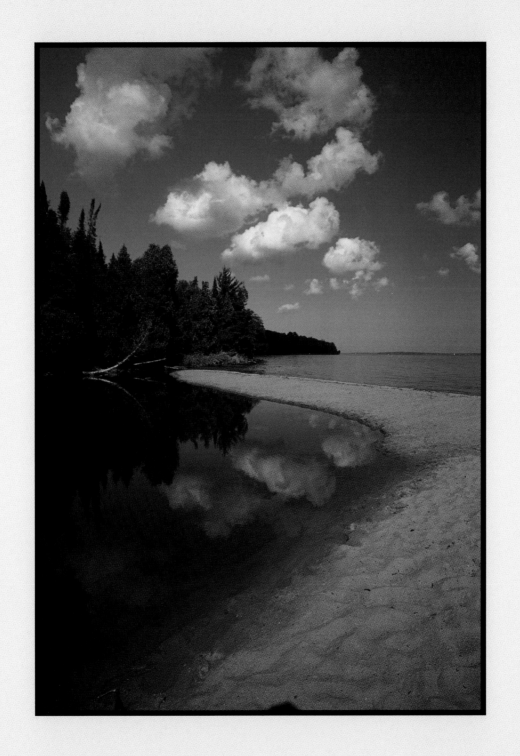

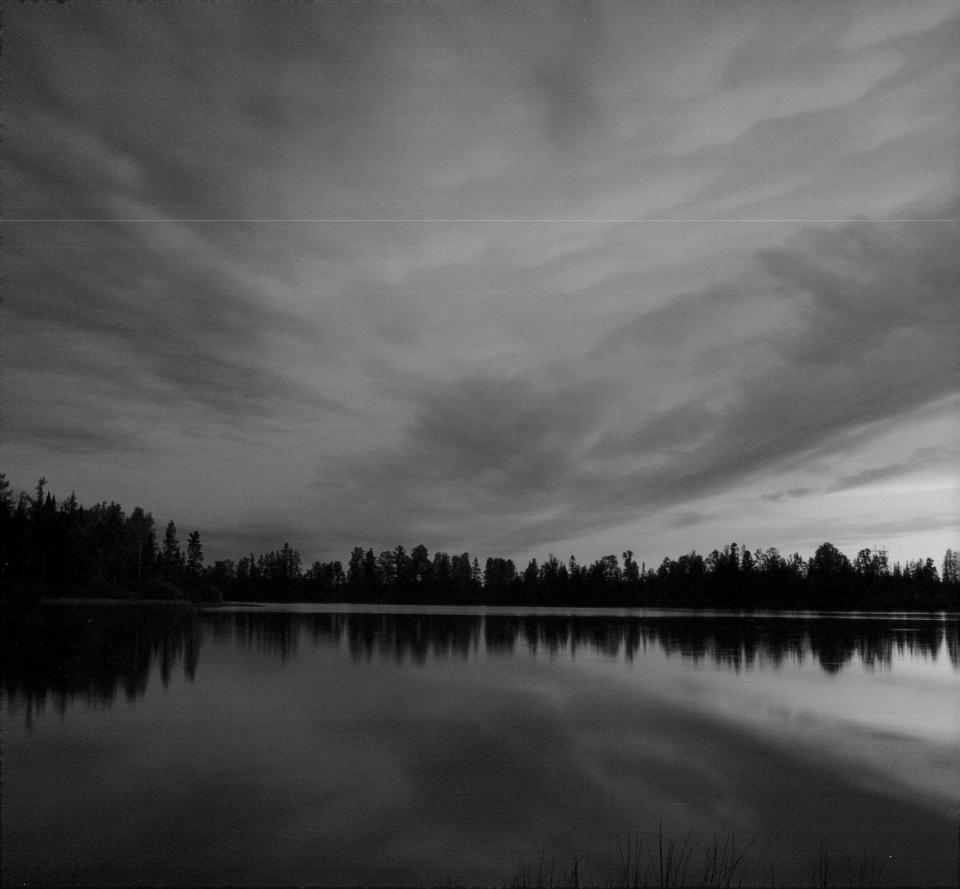

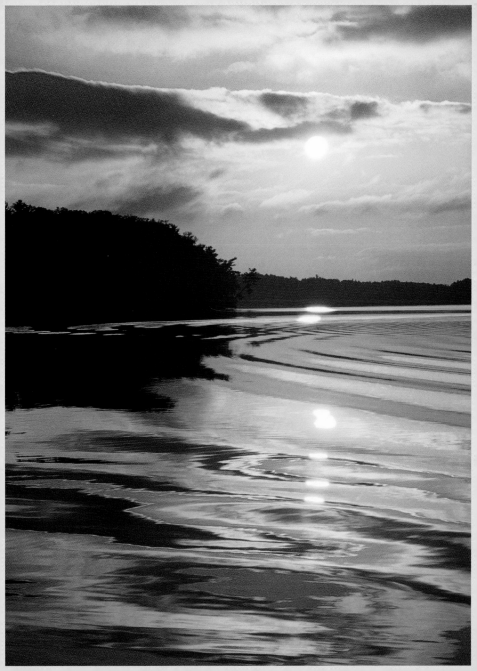

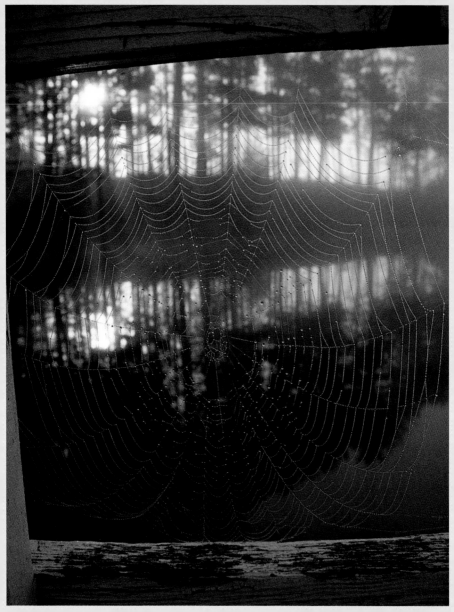

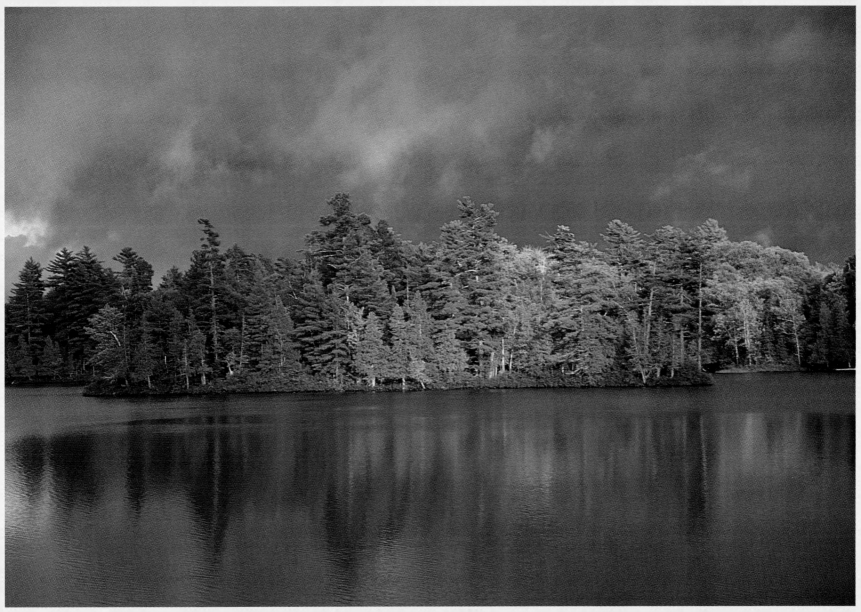

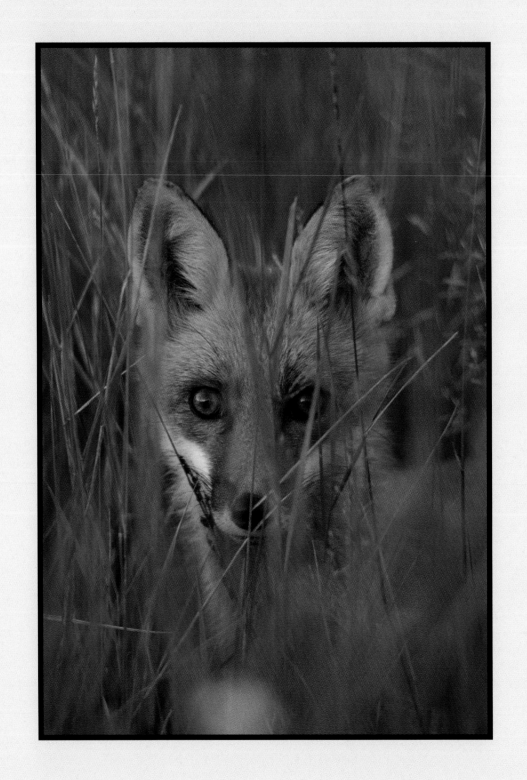

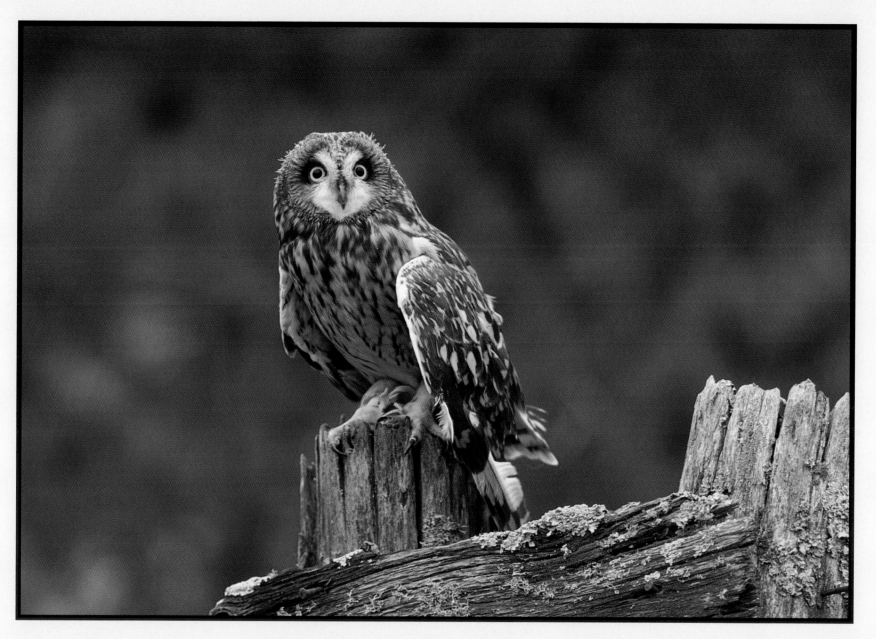

Short-eared owl, above, an out-of-the-ordinary resident.

Left: Wild eyes may be watching you. The red fox is a sly and mischievous animal common throughout the North.

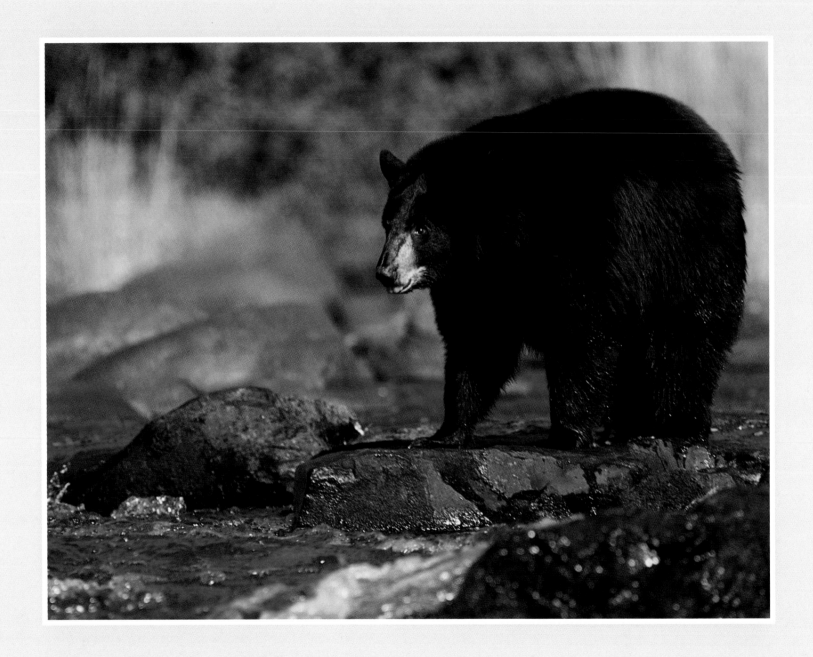

Black bear out for an afternoon drink

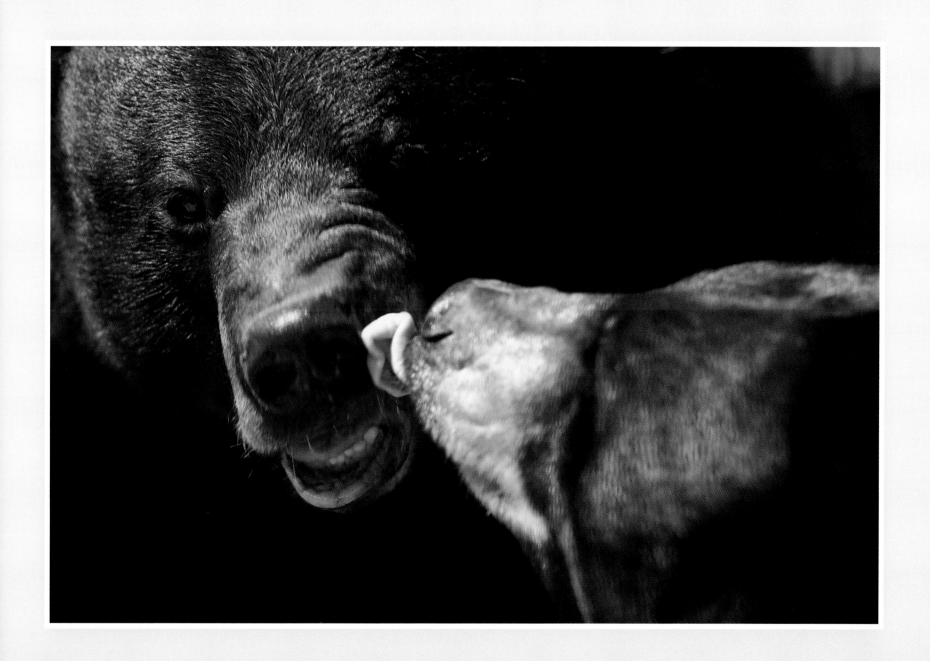

Even bears need a little love.

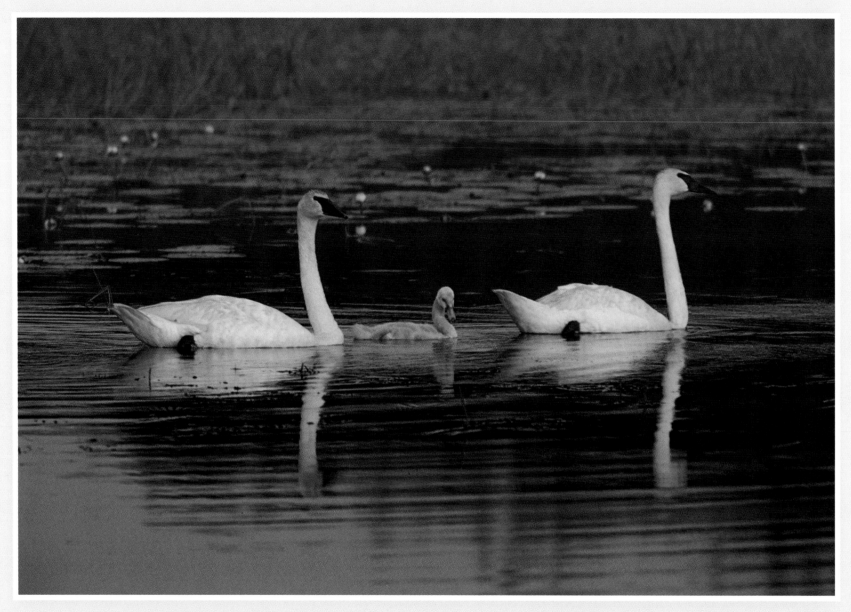

Mated trumpeter swans swim with their chick on a northern lake, one of the few successful pairs in Wisconsin. Swans were reintroduced during the 1990s, with the goal of reaching 200-300 birds statewide.

Right: Frog Lake State Natural Area in Iron County, Wisconsin.

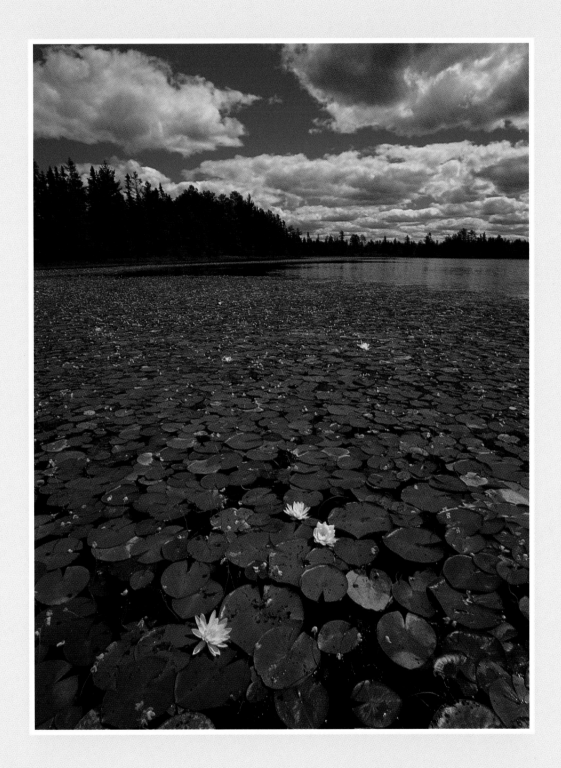

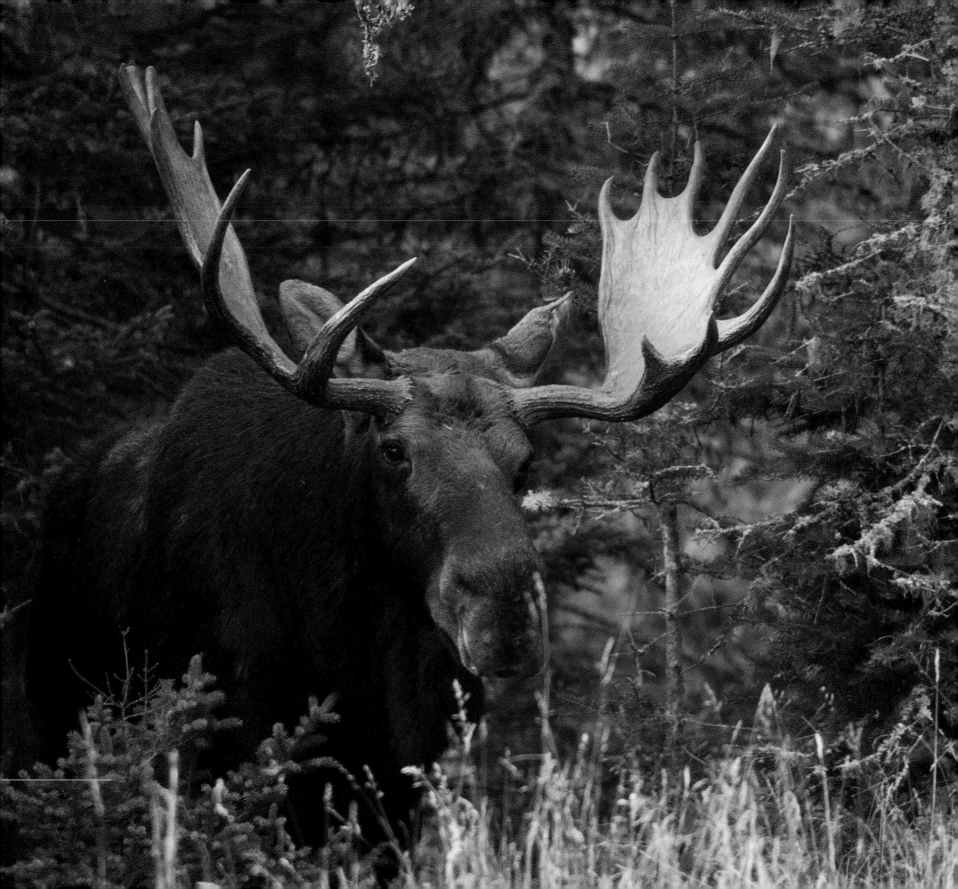

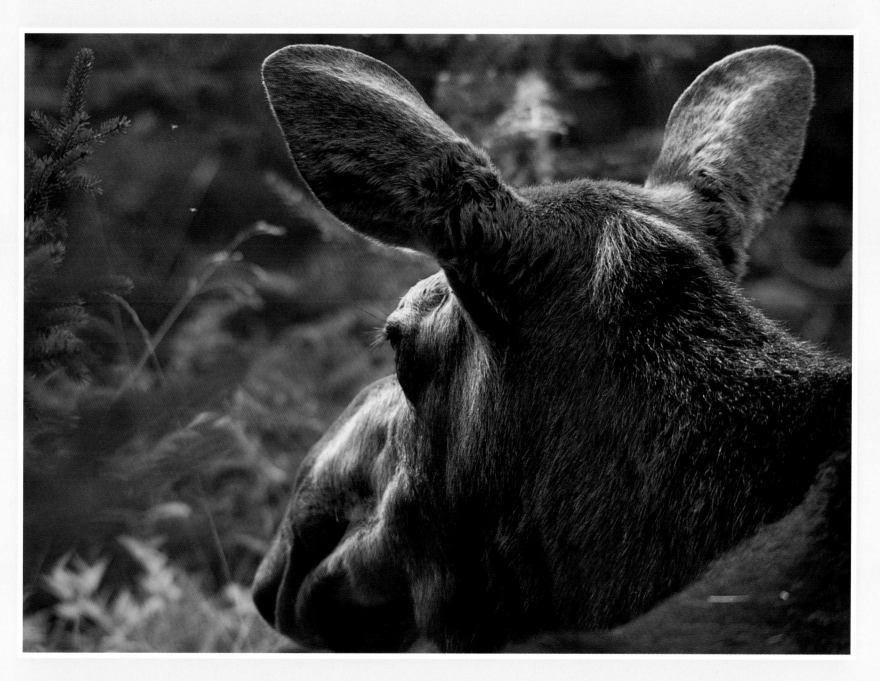

Bull and cow moose keep a wary but wishful eye on each other during the rut; Isle Royale National Park.

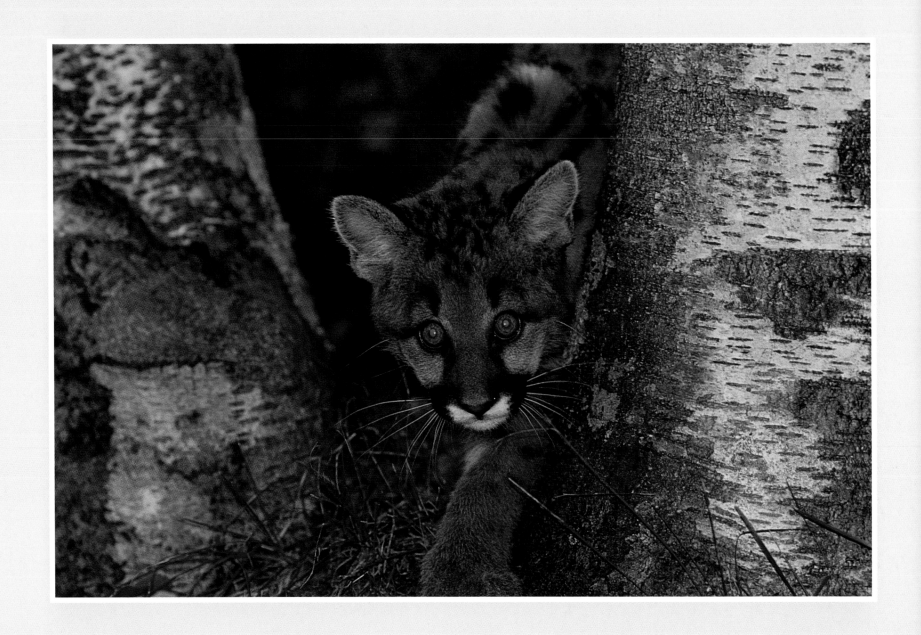

Cougar cub

Right: Superior Falls on the Wisconsin – Michigan U.P. border

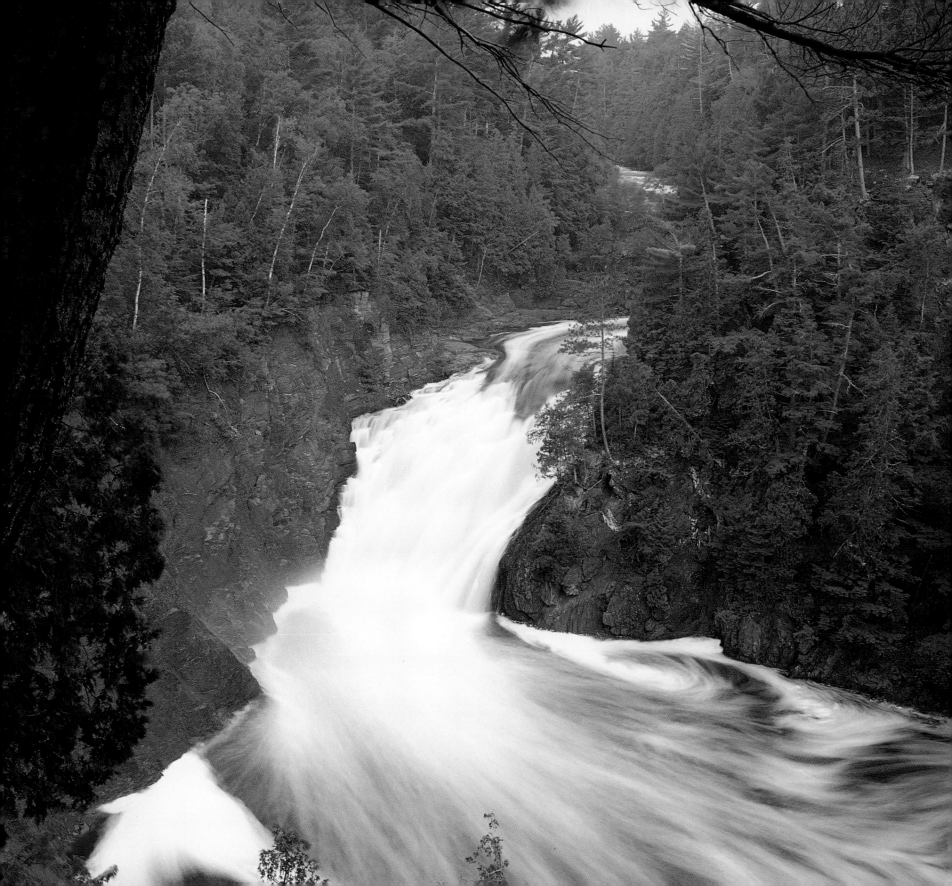

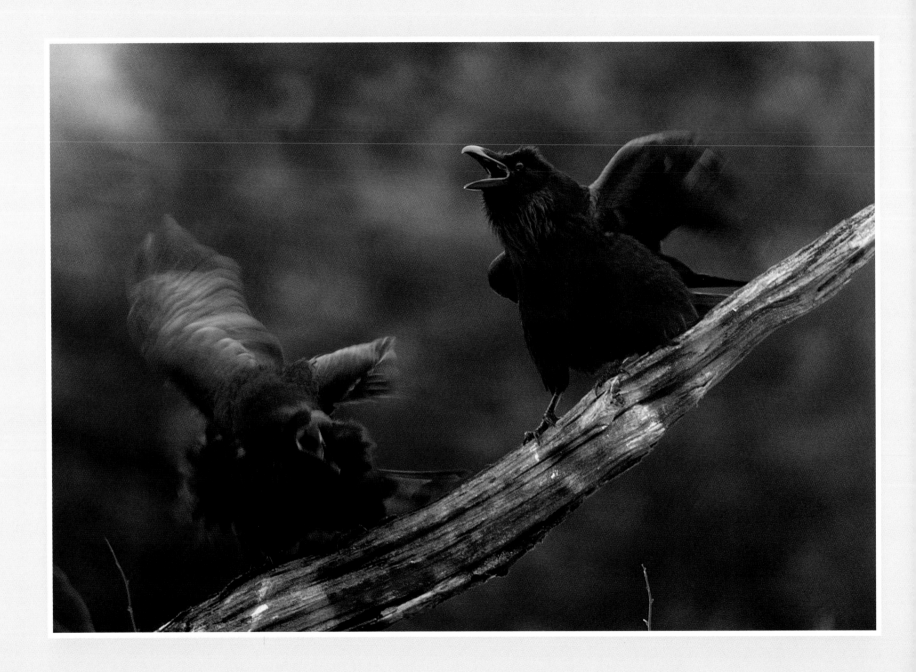

Ravens conversing. One of the thrills of photography is its ability to record
moments that are nothing but a blur to the human eye.

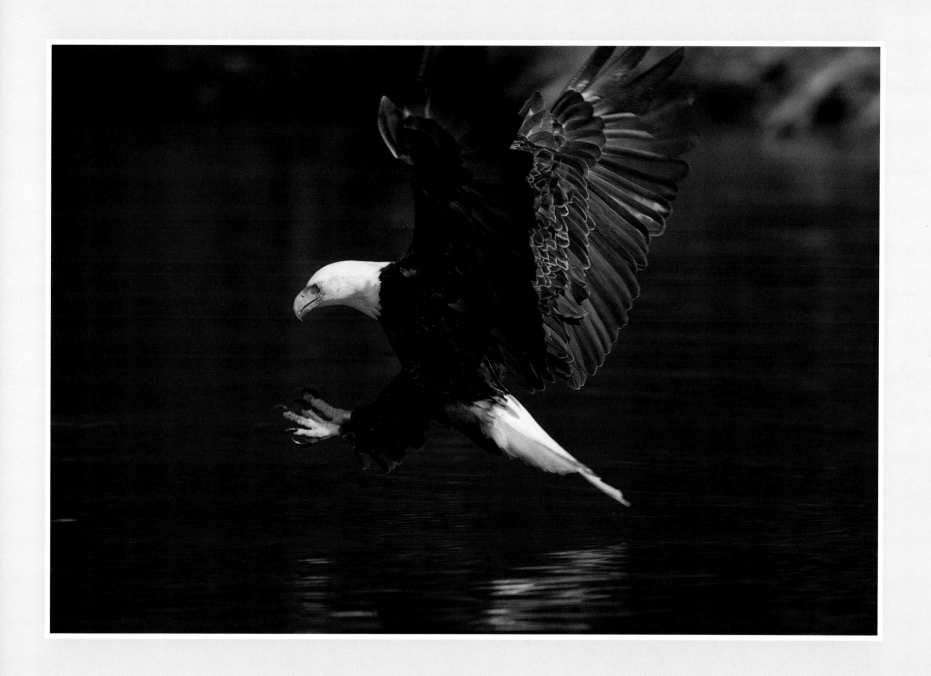

Bald eagle fishing. To photograph wildlife, you need to anticipate action.
If you wait to push the button when you see something, it's too late.

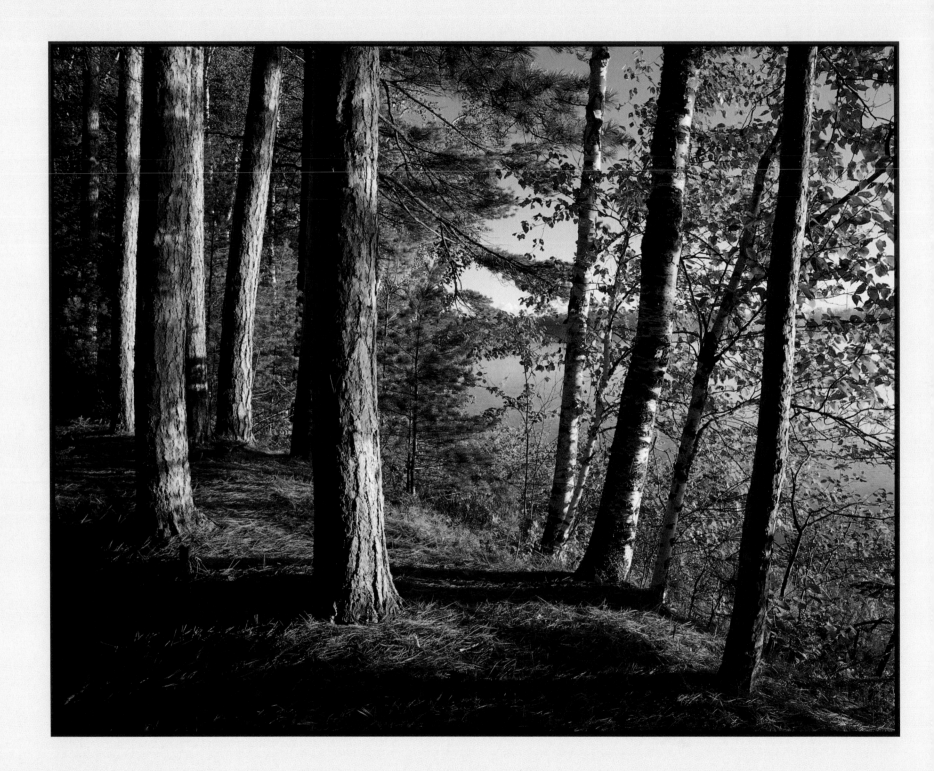

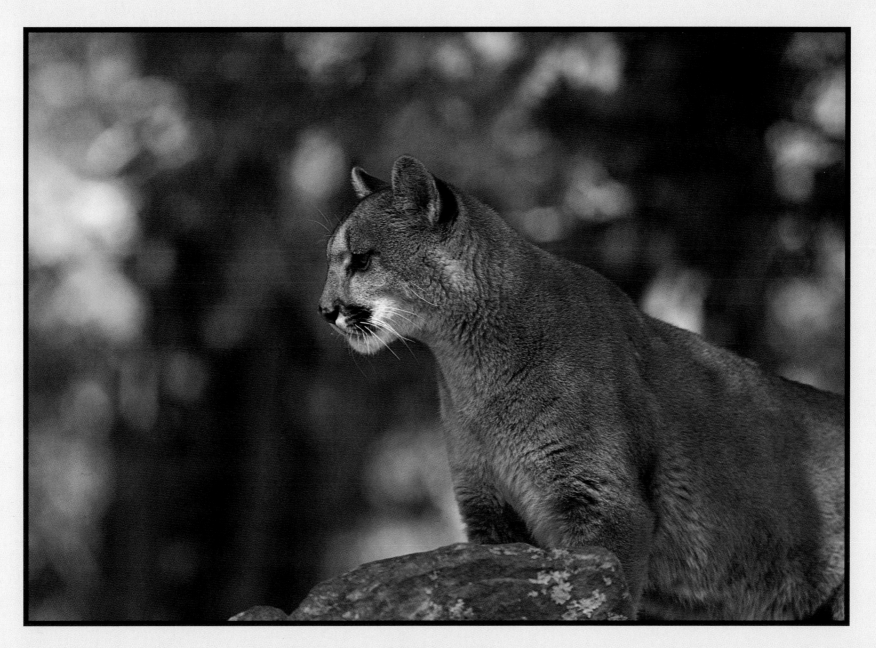

Rarely-seen cougar

Left: Classic northwoods

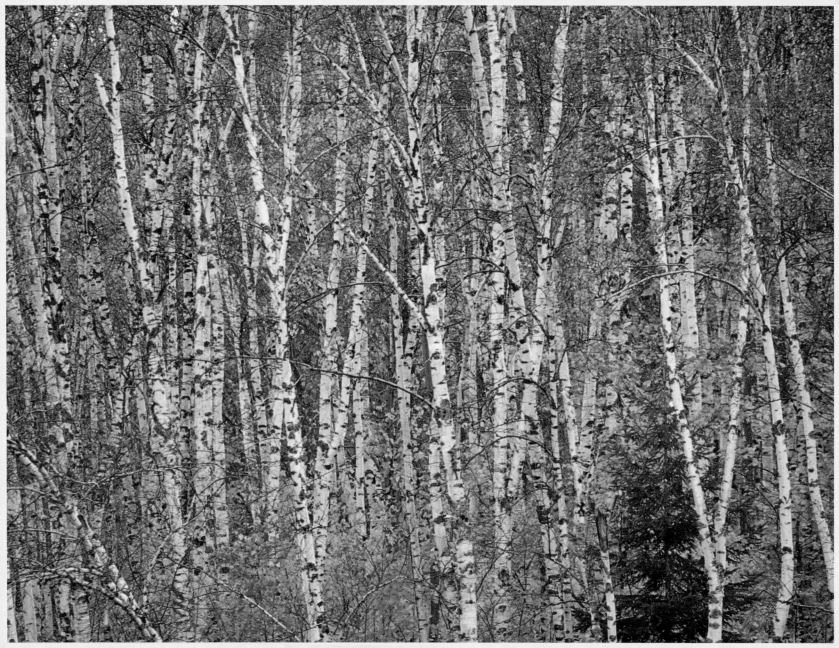

Fall

by Chad McGrath

The sweltering heat of August has melted away. Foliage mimics summer's rainbows. Lakes reflect these colors, and the sun's lower arc through the sky changes how its light sparkles on water's wind-ruffled surface. This is fall. And no one can deny fall's beauty. Who would want to?

Yet for those who love the North, there is more to fall than simple beauty. Beauty is a siren—it seduces but cannot last. Nature changes. As Emerson said, "Nature is like an immutable cloud, always and never the same." Those who love it here embrace change, and fall, perhaps more than any other season, brings change.

Most people across the northern states would say fall begins in September. Go farther north and fall begins in August. Farther south, October is the month. But to an astronomer it begins everywhere in the northern hemisphere with the autumnal equinox. That's when the earth has tilted on its axis, so the sun's rays point directly at the equator. This is generally around September 22. As fall progresses, the earth's North Pole tilts away from the sun and its rays strike north of the equator at increasingly more slanted angles. At the North Pole, a rotund earth blocks the sun's direct rays from reaching it for six months—from the beginning of fall until the beginning of spring.

While the kick of celestial mechanics trips some people's triggers, most folks experience fall more sensually. Fall inspires feeling. Many feel a loss—of summer, of a garden, of a potted geranium sitting on the porch, of the time spent at a summer home. But for those who love it here, there is a feeling of challenge and exhilaration. From the first northwest wind sweeping through white pine branches to the delicate coating of ice crystals on tan

seed heads to that inevitable hard freeze, we excitedly prepare ourselves for what's to come. Wood gets cut. Favorite jackets are pulled from closets, gloves lifted from drawers, yards tidied, piers brought onto land, boats put away. Some labors are bittersweet, but we'll be ready. Even as late September's sun warms us, we know what's ahead.

Other animals know, too. A bear stalks through her misty realm, gorging on berries aplenty—pin cherry, chokecherry, chokeberry, crowberry, raspberry, winterberry, blackberry, thimbleberry. She's accumulating fat that will burn off as she sleeps, then gives birth to and feeds several cubs amidst a world frozen around her. *Mom* knows what's ahead and takes advantage of fall's generosity.

A tan and gray wolf slinks along, fierce yellow-green eyes piercing the misty, dark, early morning air. His pink tongue hangs loosely out the side of his mouth. His nose senses hare. Breakfast. Slink becomes lope, then trot, then dead run. But the hare is gone. Swept off its feet, it has taken flight. High in a golden-leafed maple sits the nighttime monarch, pulling flesh from still-warm bones.

He ruffles his feathers against a stiff Canadian breeze, and with a hoot continues his repast.

With the north wind comes a fragrance—something fresh, unique to fall. It is an essence of pine and fir, sphagnum and sweetfern, alder and ash. The north wind blowing across a lake smells differently than a south wind blowing across the same lake. And there's the smell of fallen leaves—usually fresh and somewhat woody, but sometimes a wetter, musty odor—almost fermented.

You can hear fall. The crunch of leaves underfoot—yours, a friend's, a deer's, and even a featherweight vole's. Stand silently in a quiet autumn woods and you can hear a single leaf drop from a tree. It audibly glances off branches as it falls, then rustles other leaves as it hits the ground. Plummeting acorns sound like gunshots as they bounce off hard earth or tree trunks. Leaf-scuffling red squirrels scurrying from tree to tree have caused more than one bow hunter to look for a deer that wasn't there.

Perhaps more than any other sound, the honk of geese heralds fall. Skeins of them flap southward, talking to each other, keeping in touch. Sandhill cranes rasp their way southward too, as do thousands of other birds, most quietly slipping past without our noticing. Finally we experience yet another fall phenomenon—the absence of bird song. There are no more evening robin calls. Mornings become almost *too* quiet.

Fall's feeling, fragrance, and sound fill our senses, but what does it *look* like? Fall brings nakedness. Bare twigs reveal soothing depth, fine texture, spiraling trunks. But needled trees remain reassuringly in our vision, ready to catch snowflakes. Calming evergreens, dense and soft, wave in November's breeze.

Fall also brings ripeness and color. Plump scarlet apples hang fetchingly from nearly leafless branches. Rubenesque orange pumpkins lie alluringly on bare ground. Tan grasses await the coming white wonder. Great round sienna hay bales dot fields between woodlots.

But it's the coloring of the leaves that draws people north. This riotous, ephemeral, almost magical process occurs as photo-

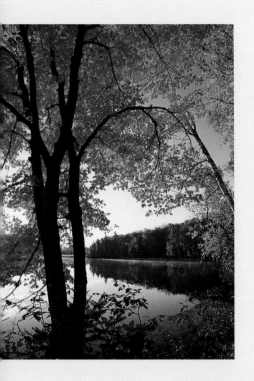

synthesis slows down in the shortening days of September. Chlorophyll, whose green so dominates summer, loses its control. Other chemicals now shine. A group called anthocyanins glows red, and another called carotenoids screams yellow. Blends of these pigments provide the amazing spectrum we see each autumn.

High ground maples blaze orange. Silver maple in moist river turn yellow. Red maples, also of wet places, glow fiery scarlet. White ash plot a purple hue. Birch brandish saffron leaves, spicing up the rest, while understory plants creep below the show, painting their own canvas with namesake colors—hazelnut and ironwood brown, bluebeech khaki, thimbleberry tan, moosewood butter, raspberry red, blackberry purple, mapleleaf viburnum mauve. It's enough to make a paint store turn green with envy.

And in the eastern evening sky, above the tamaracks, a huge yellow-orange orb peaks over needled spires. Minutes before, these spires held reflected sun as golden as a polished nugget. Cold air creeps into the sphagnum, where the larch sink their roots. Labrador tea leaves curl, conserving moisture for a long, dry winter. A few dark red ilex berries dot bushes—tomorrow's food for a lonely waxwing. In the distance, a wolf howls. The land will freeze tonight for the first time in months. This is fall's harsh gift. Life's cycle will repeat, as it has for eons. And we of the North will look forward to more beauty. What a wonderful place we live in.

Since 1994 Chad has written five books about hiking, mountain biking, and cross-country ski trails in the Midwest. His latest book, Great Cross-Country Ski Trails, *highlights ski trails within the Lake Superior watershed from Thunder Bay Ontario, through Minnesota, Wisconsin, the Upper Peninsula of Michigan and into Ontario at Sault Ste. Marie. Chad also owns ClearView Nursery. He operates the nursery and several retail outlets from his home in Springstead, Wisconsin.*

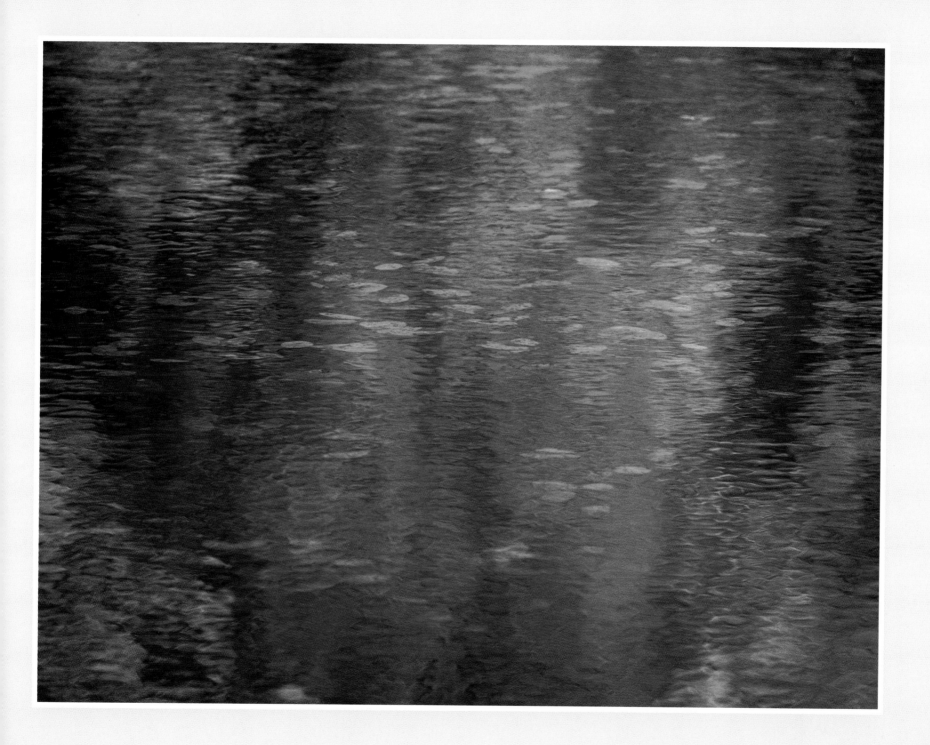

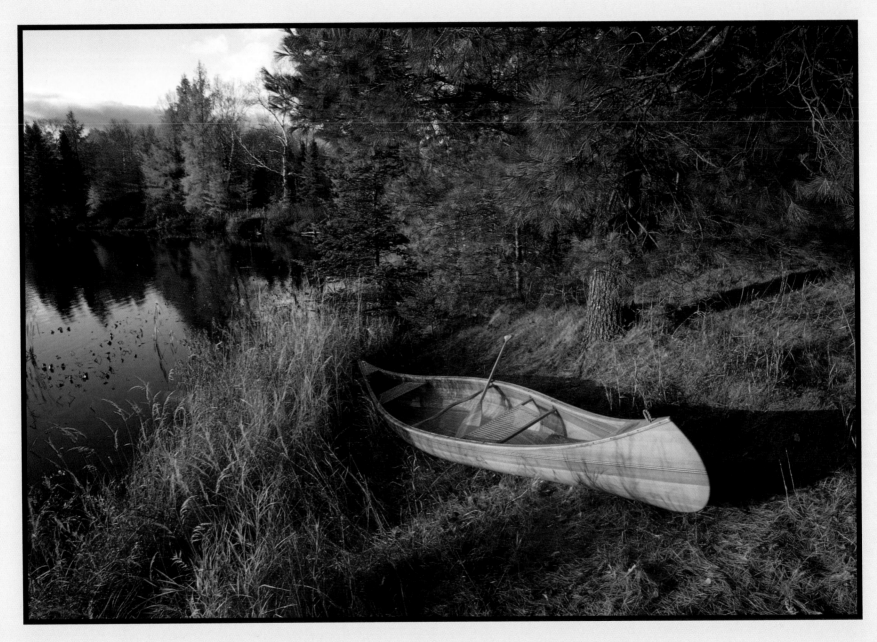

A beautiful hand-made cedar canoe ready for a paddle on a beautiful autumn evening.

Right: My favorite wildlife images depict animals as part of their environment; Bayfield County, Wisconsin.

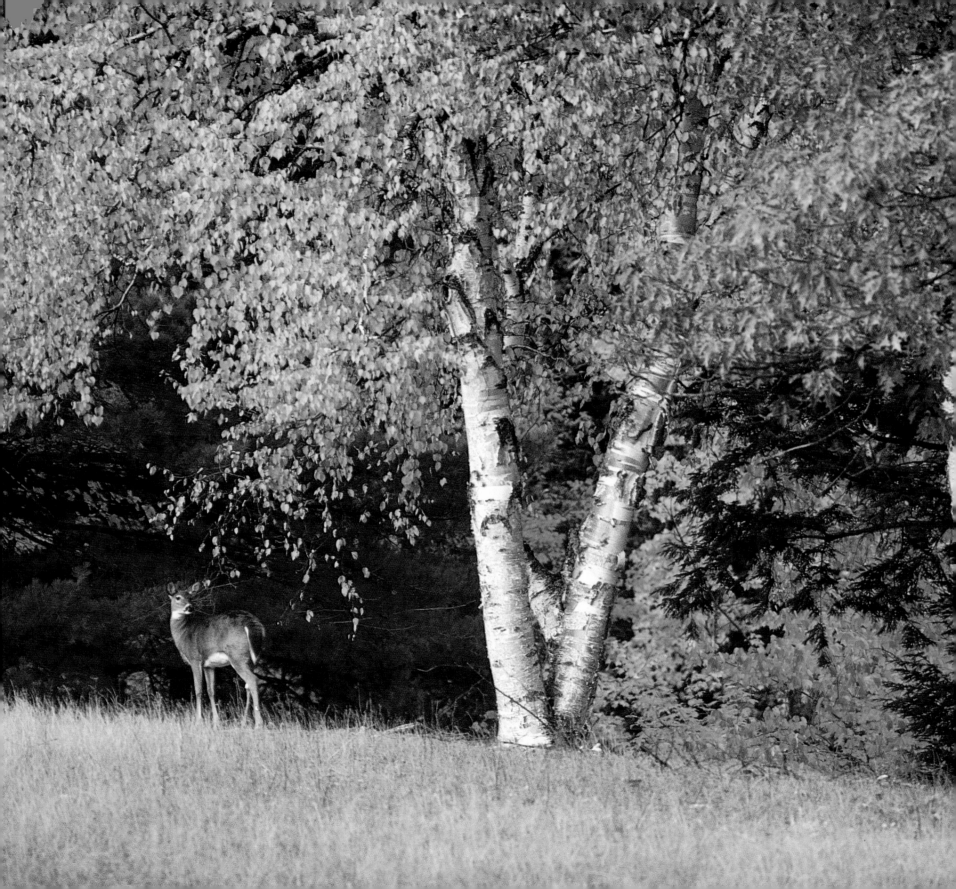

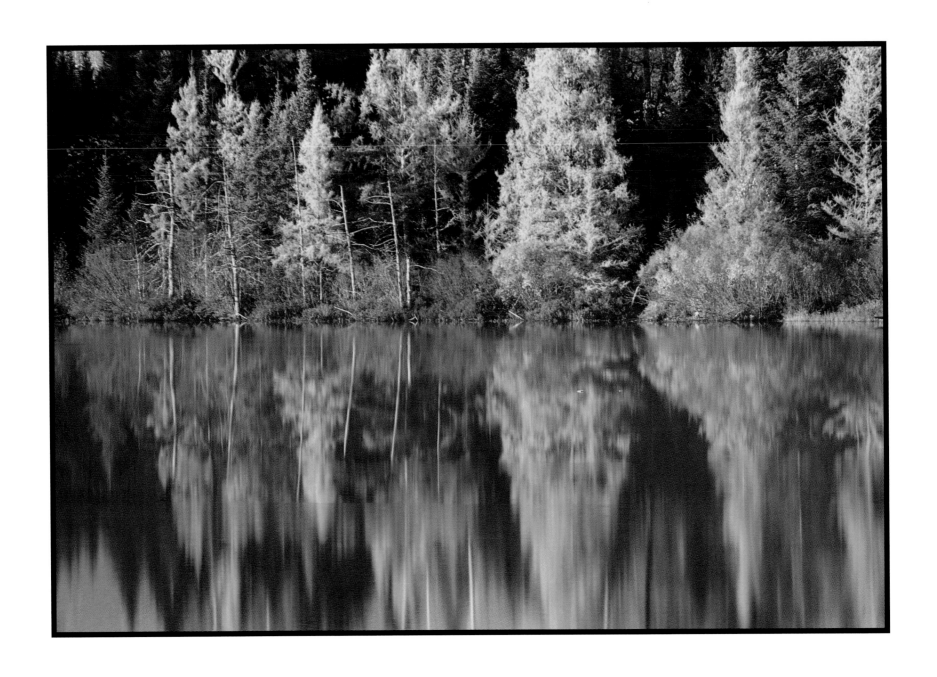

Blazing yellow tamarack; Washburn County, Wisconsin. Tamarack is one of the few conifers that shed their needles in fall.

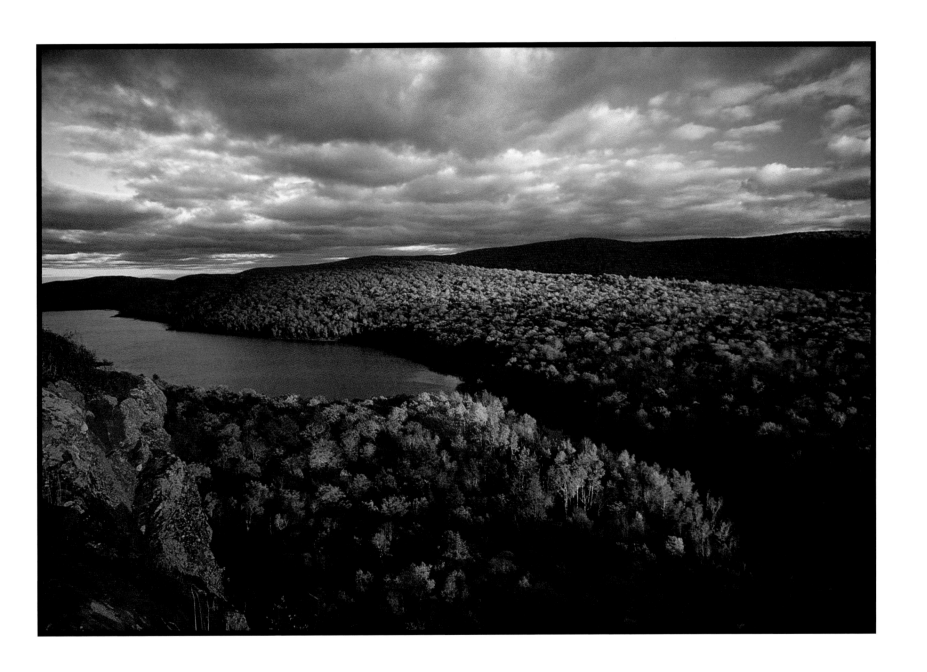

Lake of the Clouds, Porcupine Mountains State Park, Michigan

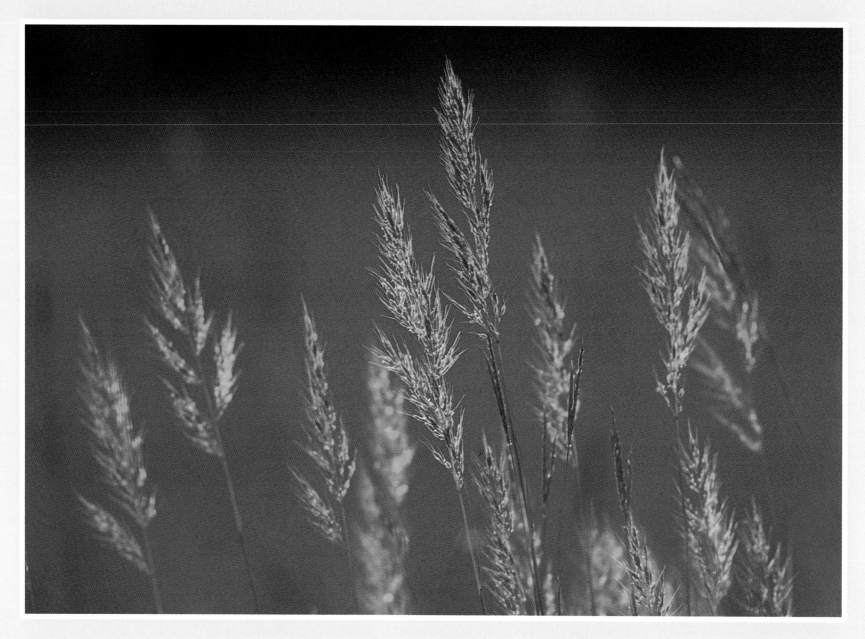

Grasses take on autumn colors as well. The North has many rich and varied grasslands interspersed with its forests.

Right: Soft, moody autumn colors can be as interesting as vibrant ones; Florence County, Wisconsin.

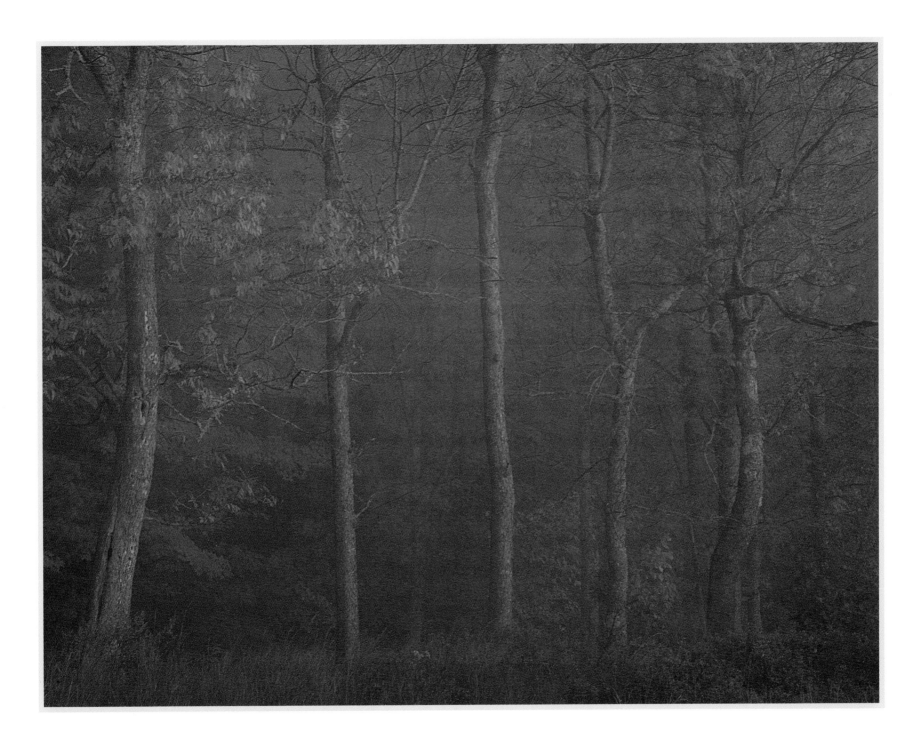

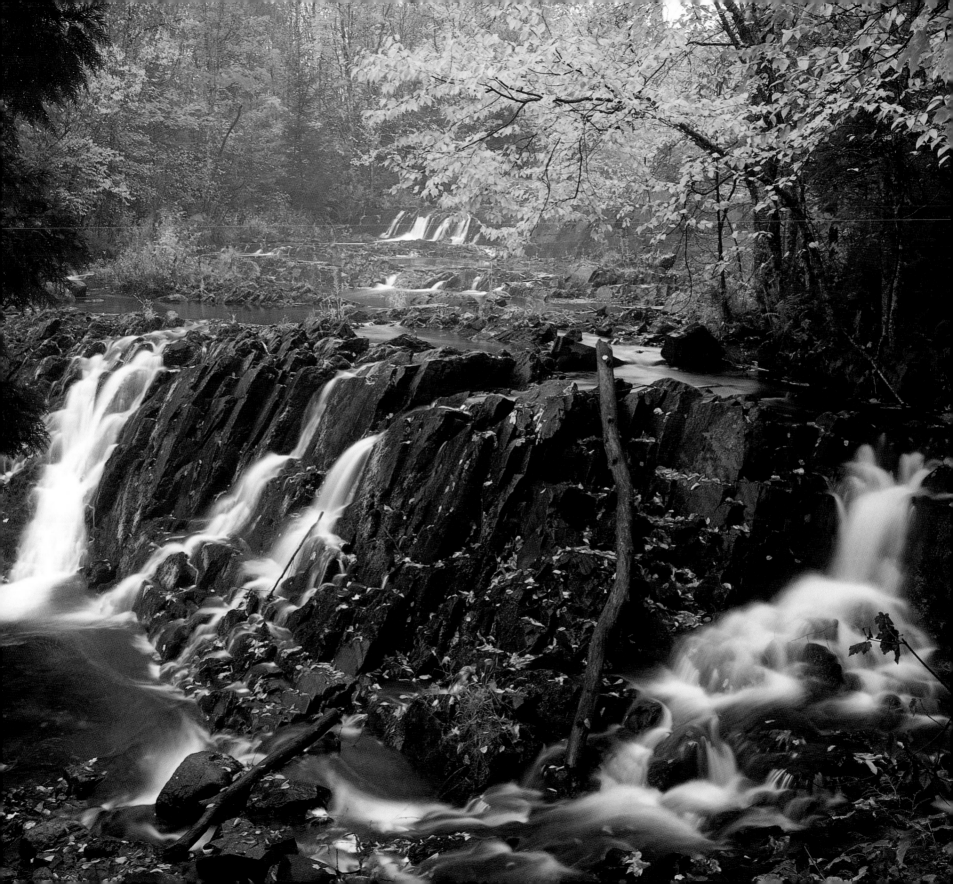

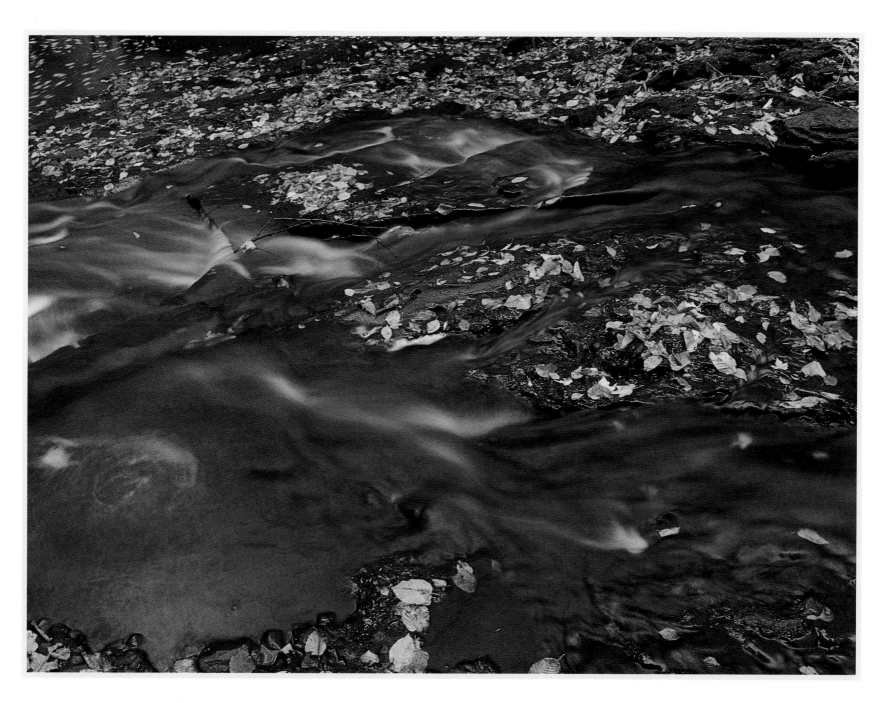

Above: Amnicon River, Amnicon Falls State Park, Wisconsin; Left: Upson Falls, Potato River, Iron County.

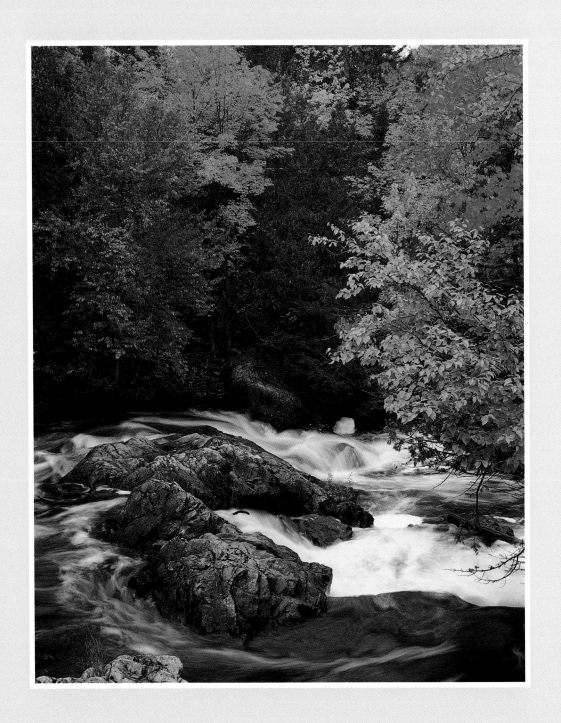

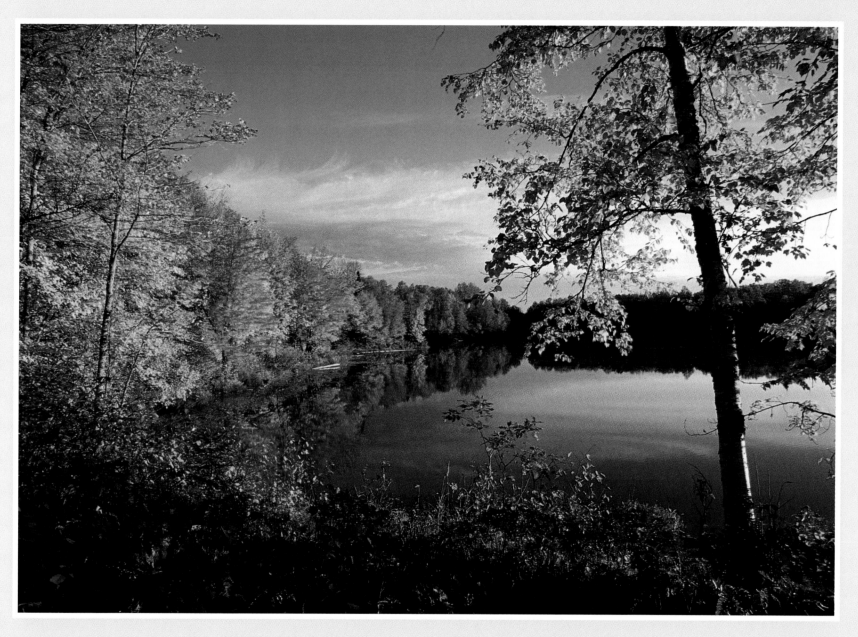

Anticipating morning scenes like this make those 4:00 a.m. wake-ups tolerable.

Left: Presque Isle River, Marenisco, Michigan

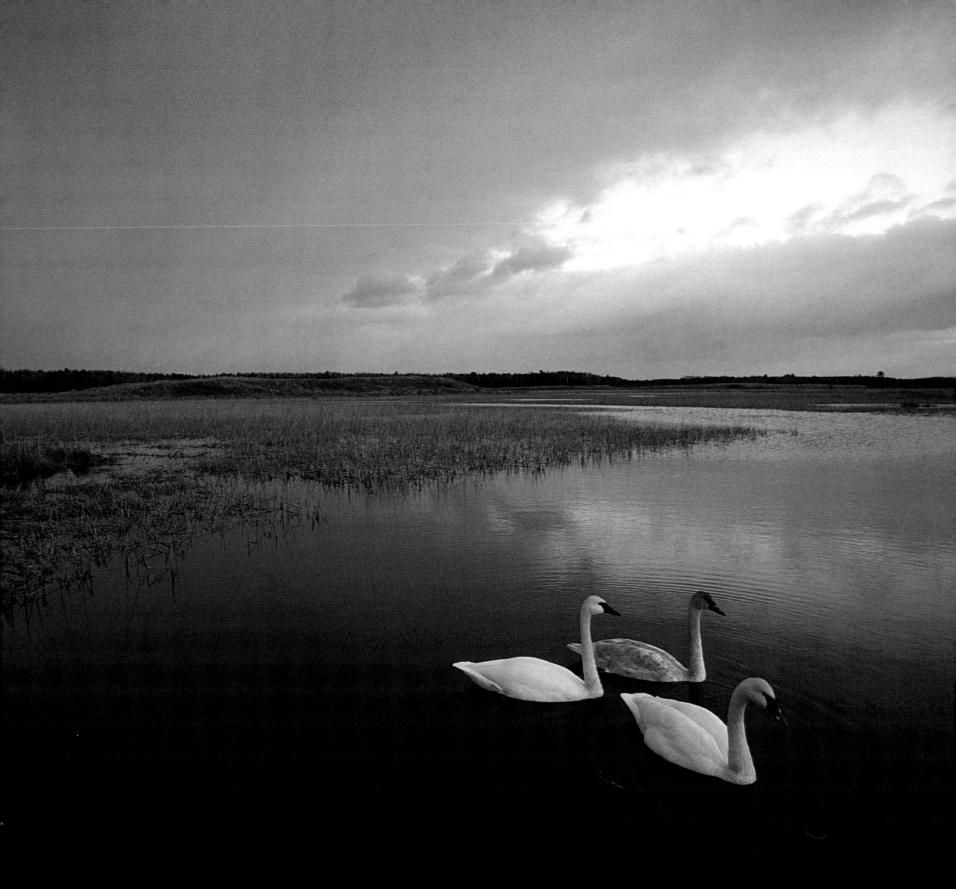

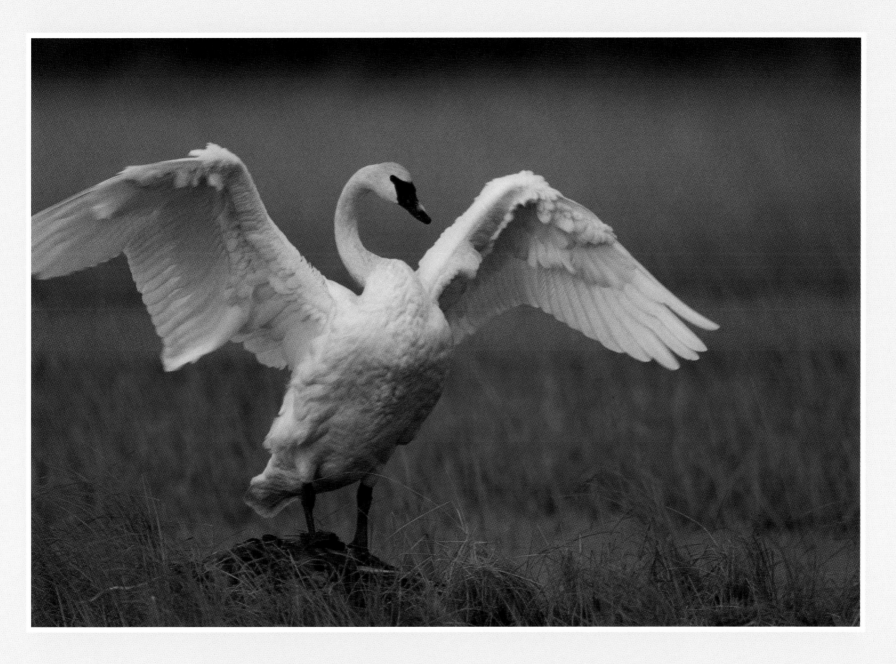

The trumpeter swan is an impressive bird with its immense size and eight-foot wingspan. They tend to be approachable, allowing the use of a wide-angle lens (left) in addition to the usual telephoto (above).

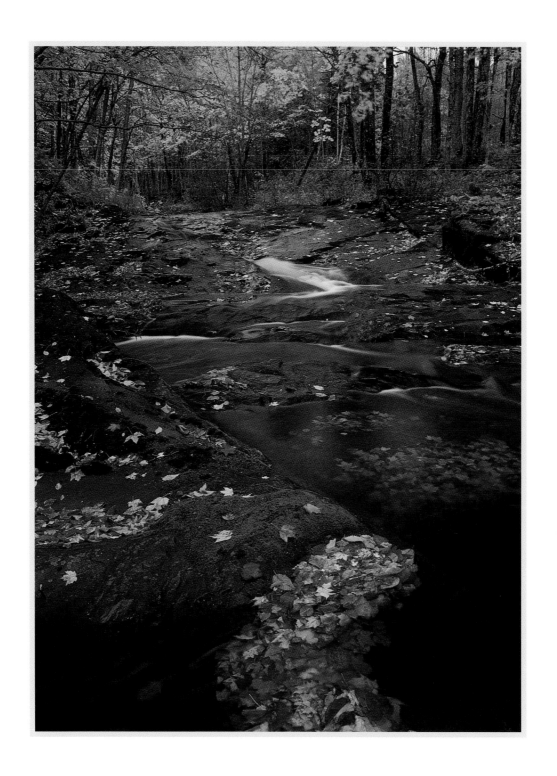

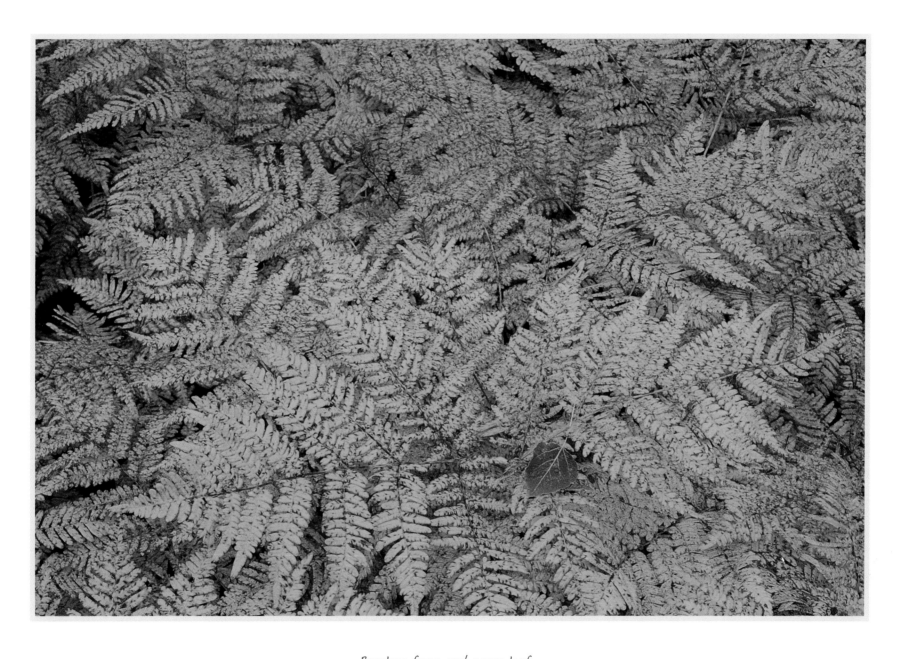

Bracken ferns and aspen leaf

Left: Film "sees" fall colors intensely on overcast days.

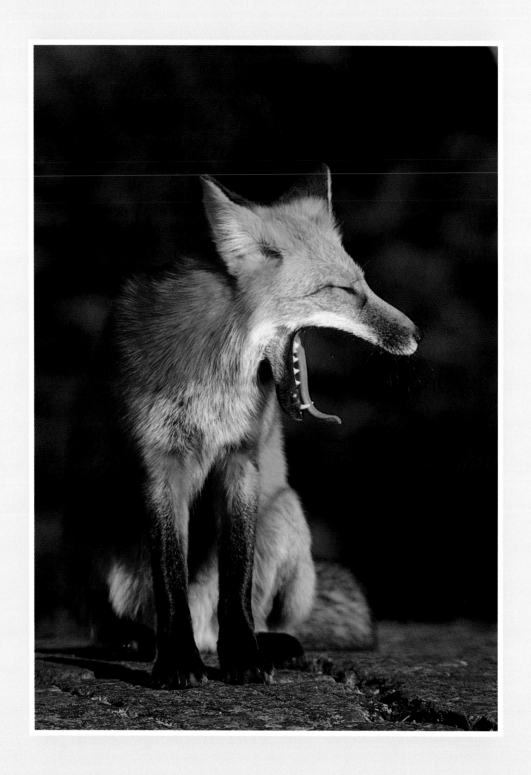

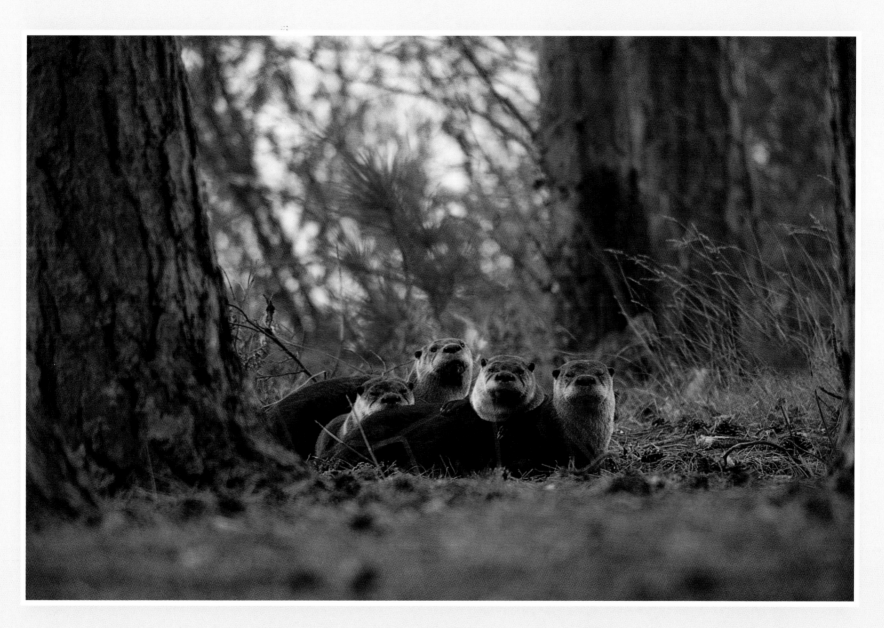

Otter family taking an afternoon nap. A favorable wind direction allowed me to sneak within photo distance.
It's unusual to find otters resting; they're normally in motion.

Left: Yawning red fox on a memorable morning; Isle Royal National Park.

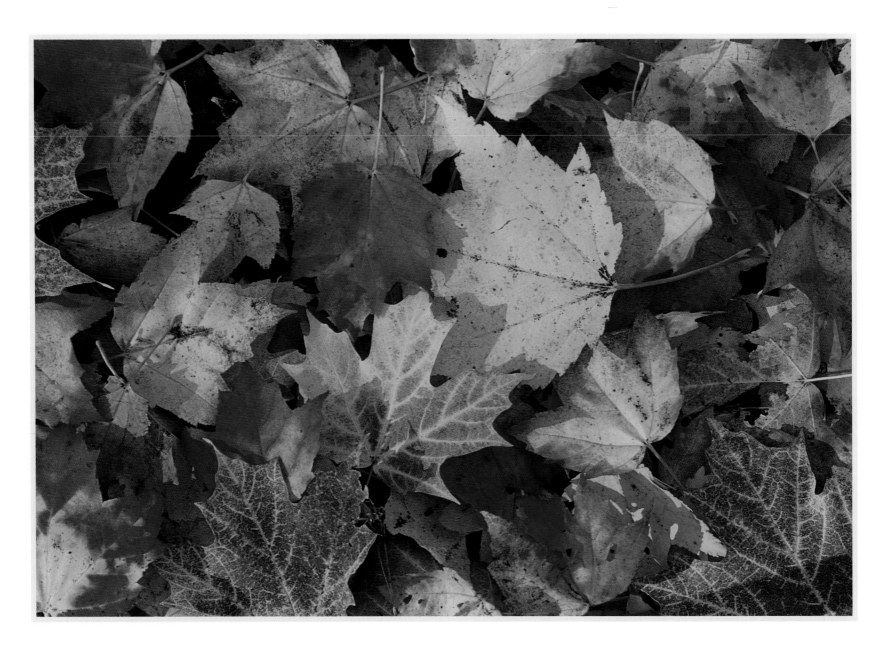

Maple leaf mosaic

Right: Carp River overlook, Porcupine Mountains State Park

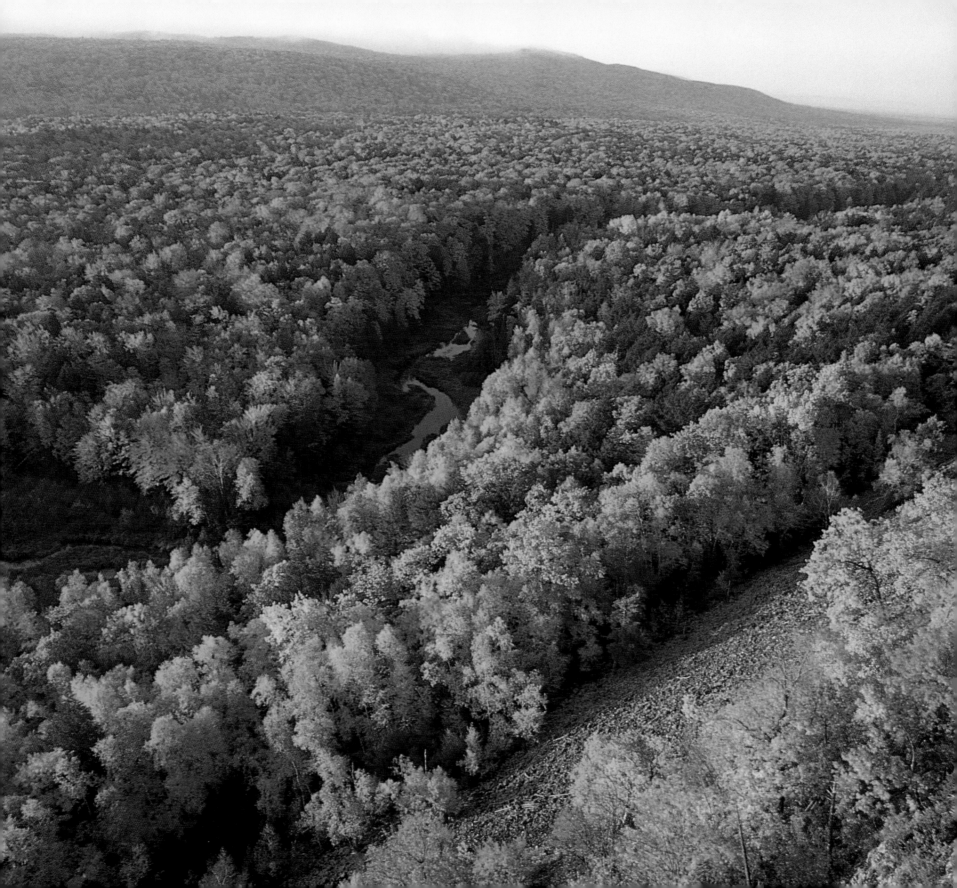

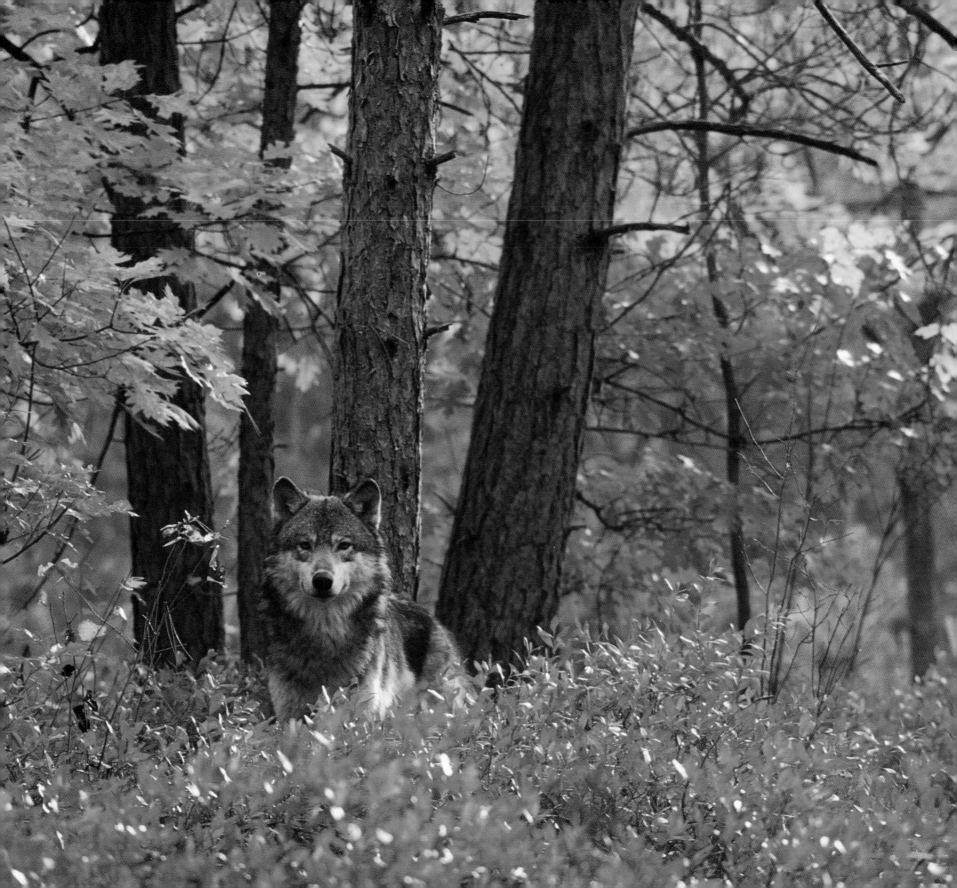

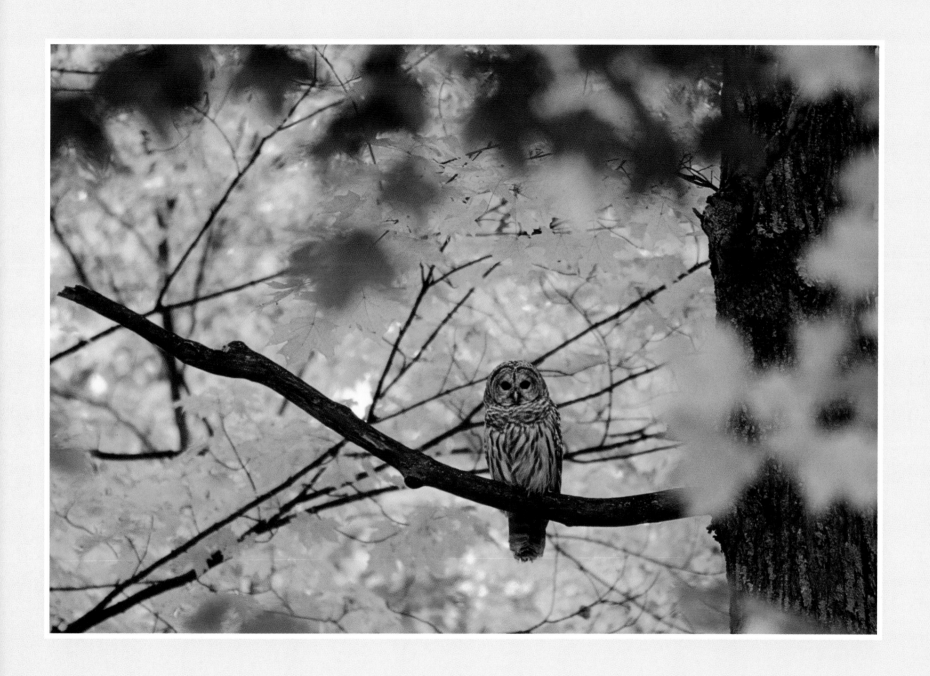

Fall woods add stunning backdrops for wildlife images. Above: Barred owl; Left: Timber wolf

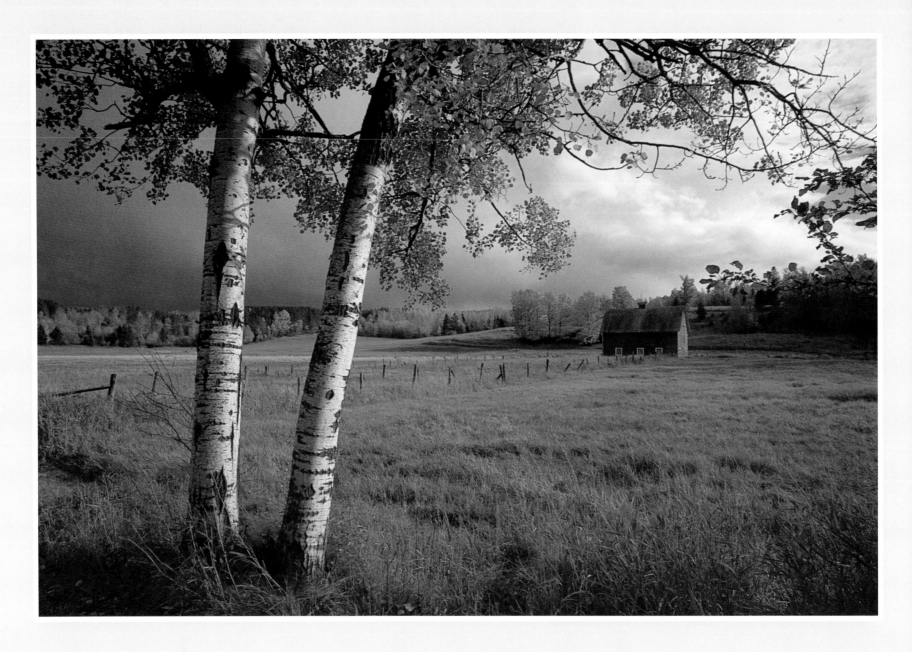

Fall clouds add drama to a Northwoods farm scene.

Right: Lichen-covered birch trees; Bayfield County.

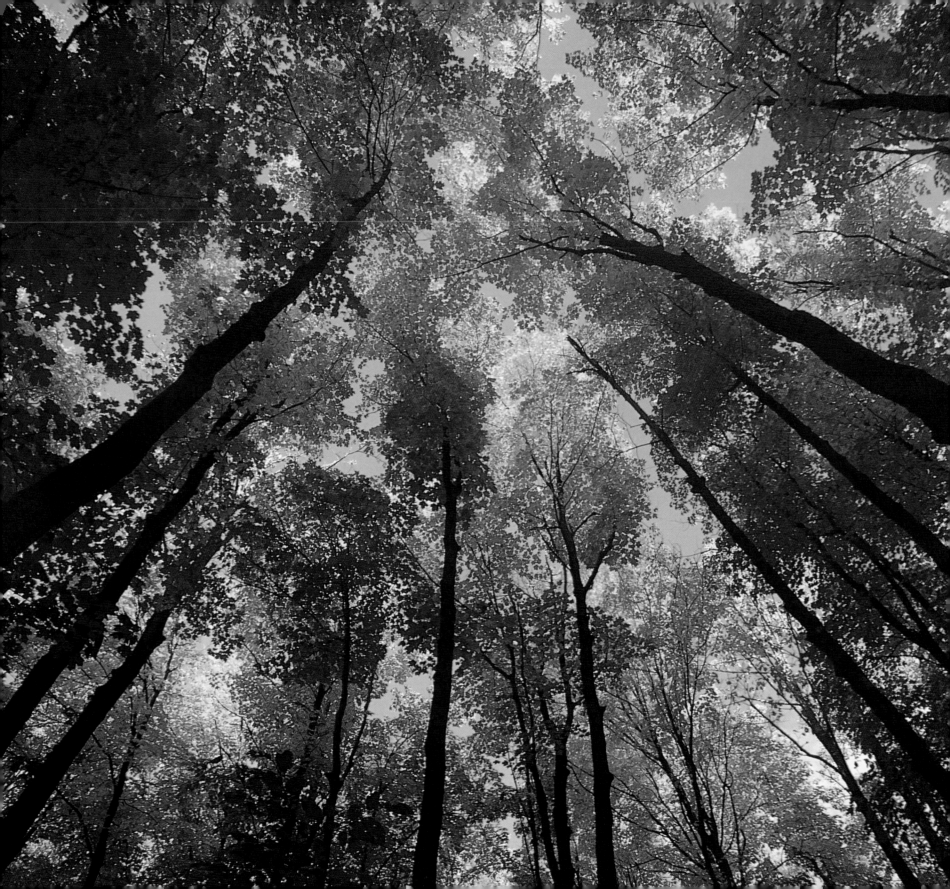

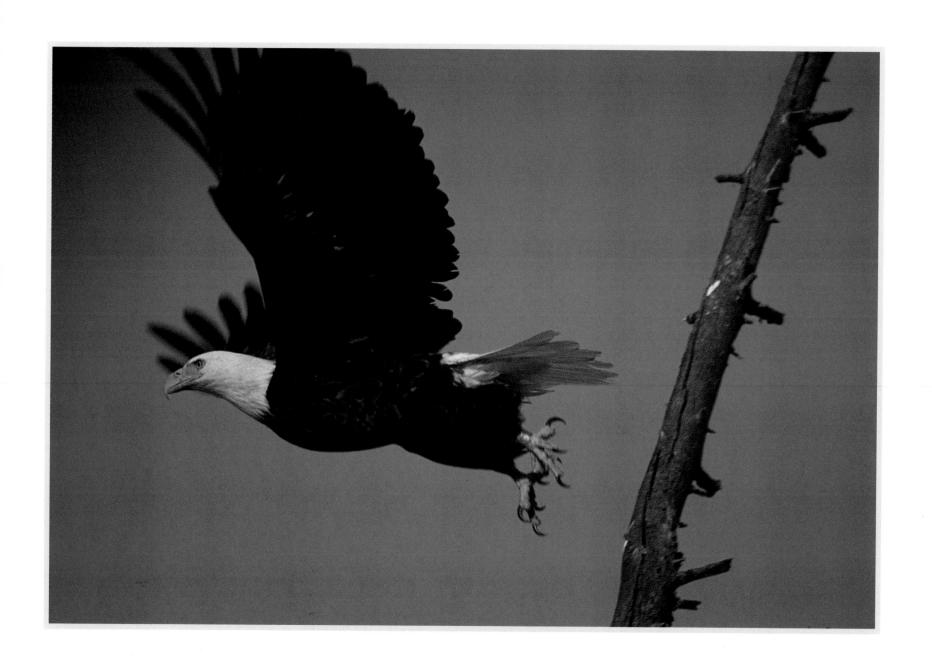

Soaring beauty

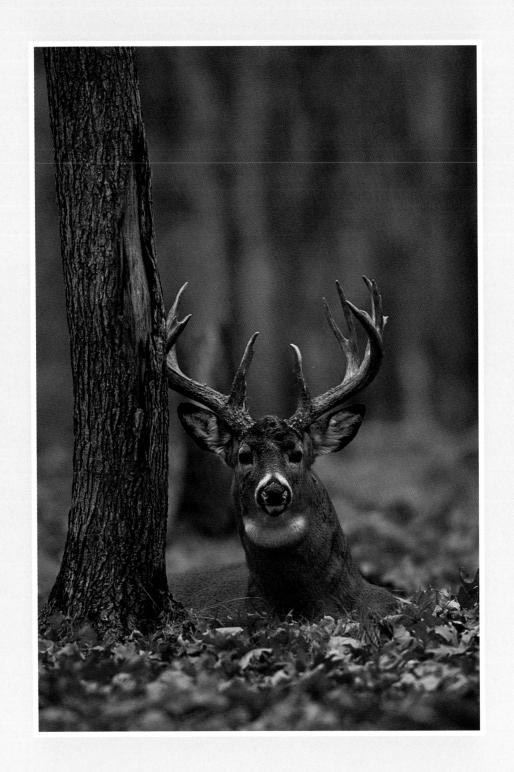

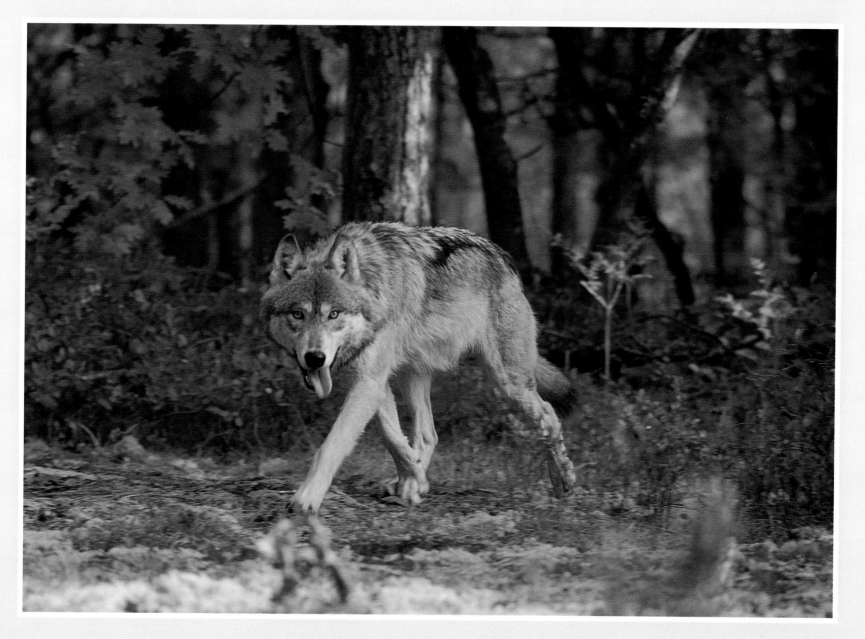

Left: Mature whitetail buck ready for the rut.

Above: What a deer sees—timber wolf hot on the trail.

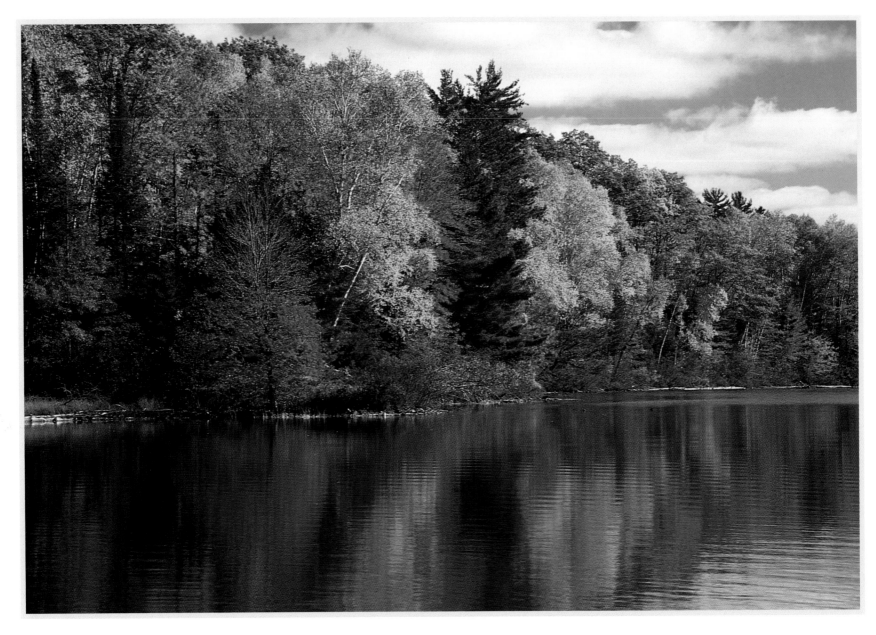

The most vibrant fall colors I've ever captured on film; Northern Highlands–American Legion State Forest.

Right: Porcupine hanging around on an autumn day.

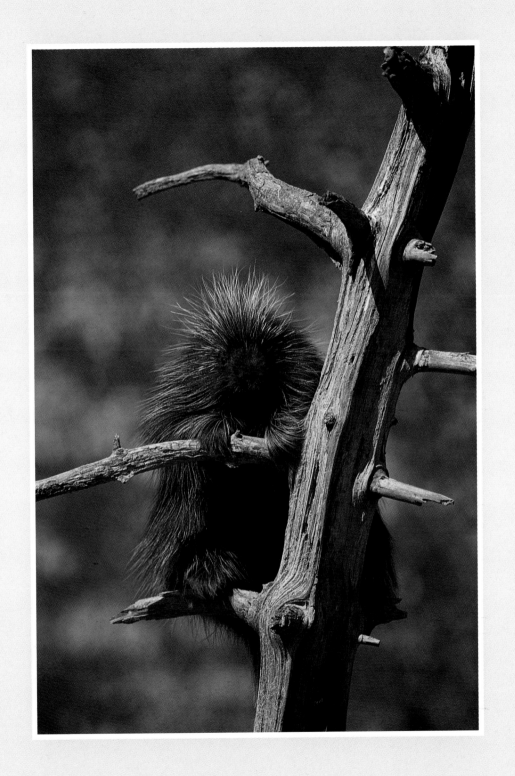

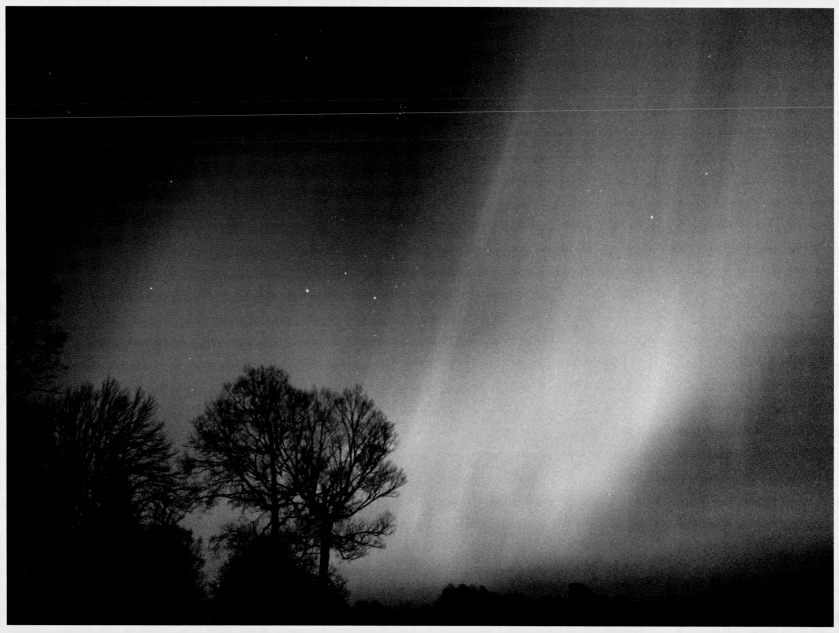

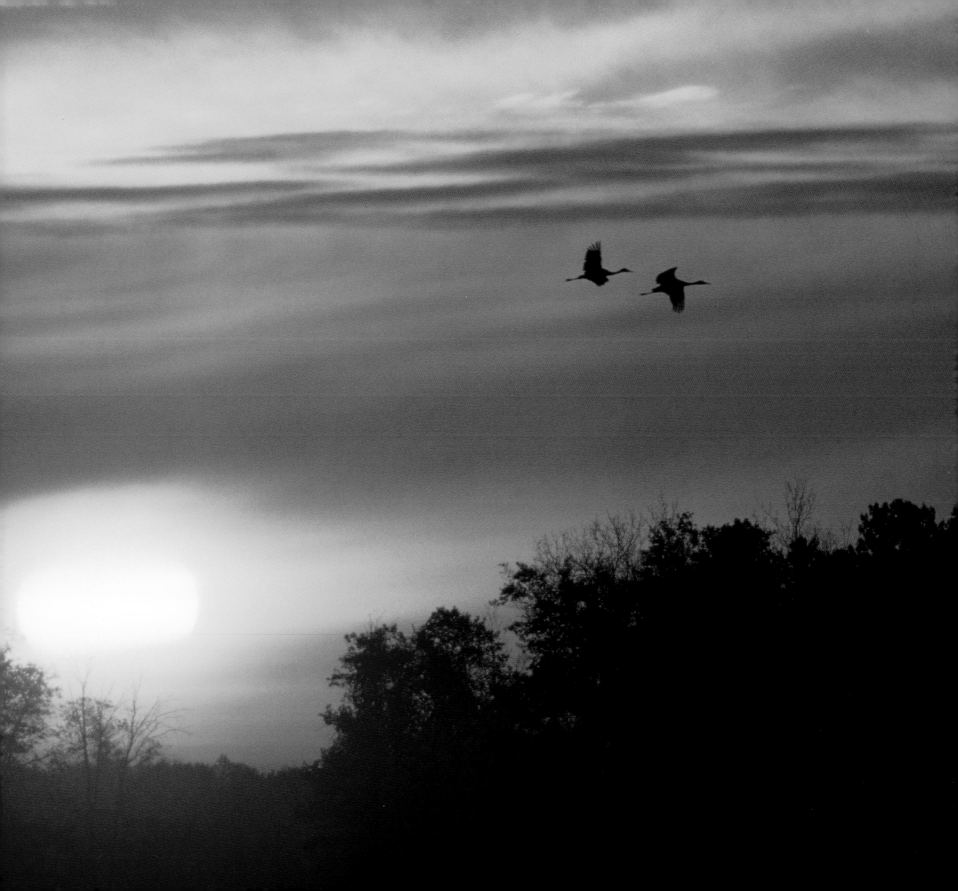

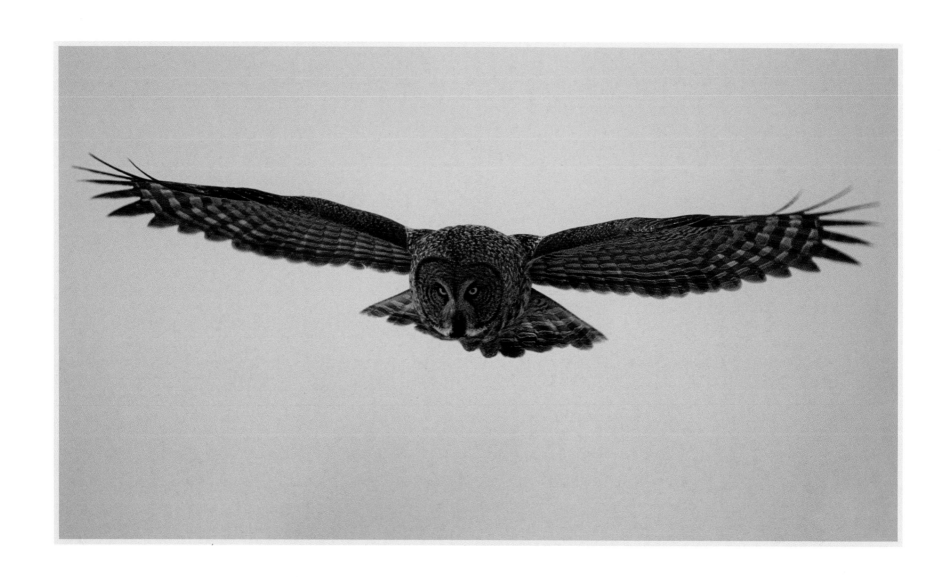

Great gray owl in flight — the largest North American owl.

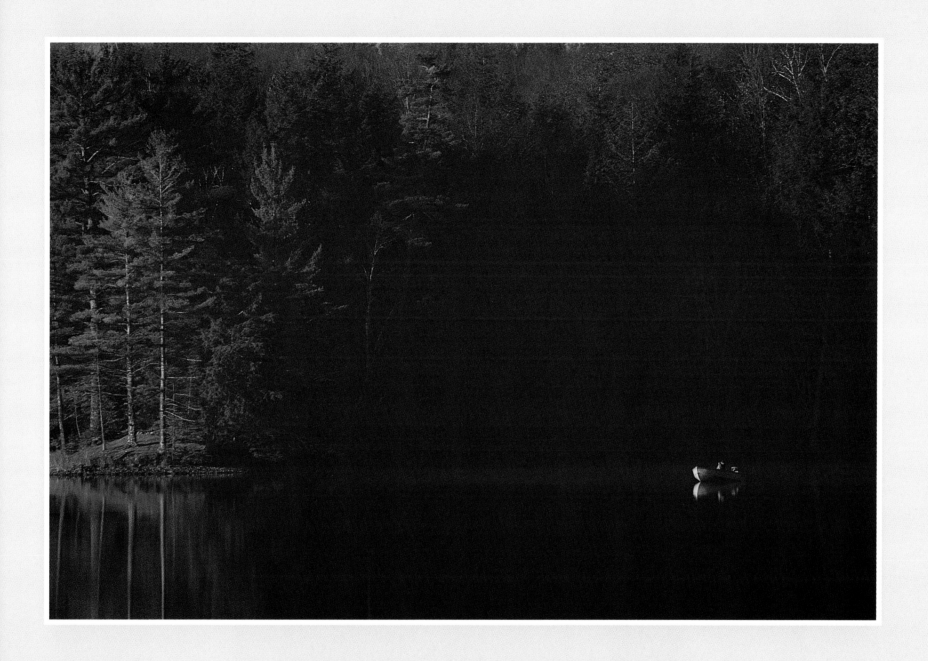

Fishermen willing to brave fall's cool temperatures often catch some impressive stringers; Turtle-Flambeau Flowage, Iron County.

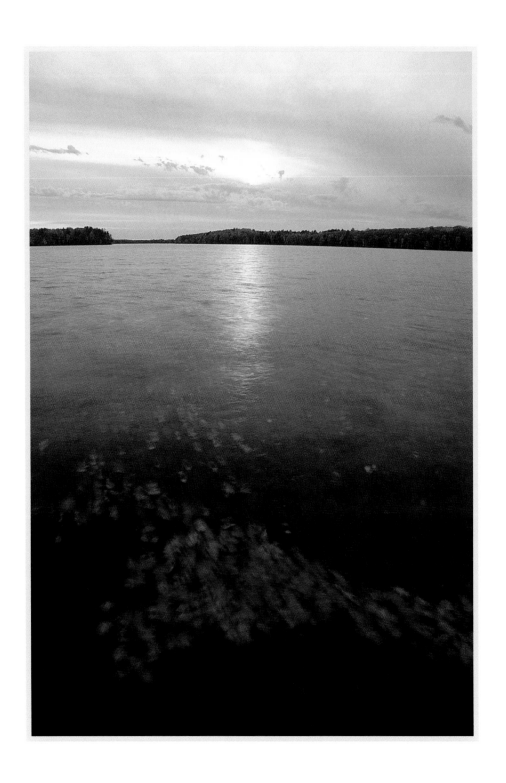

Autumn's leaves all too
quickly begin to drop or
give way to early snow;
Trout Lake, Vilas County.
Right: near Trout Lake

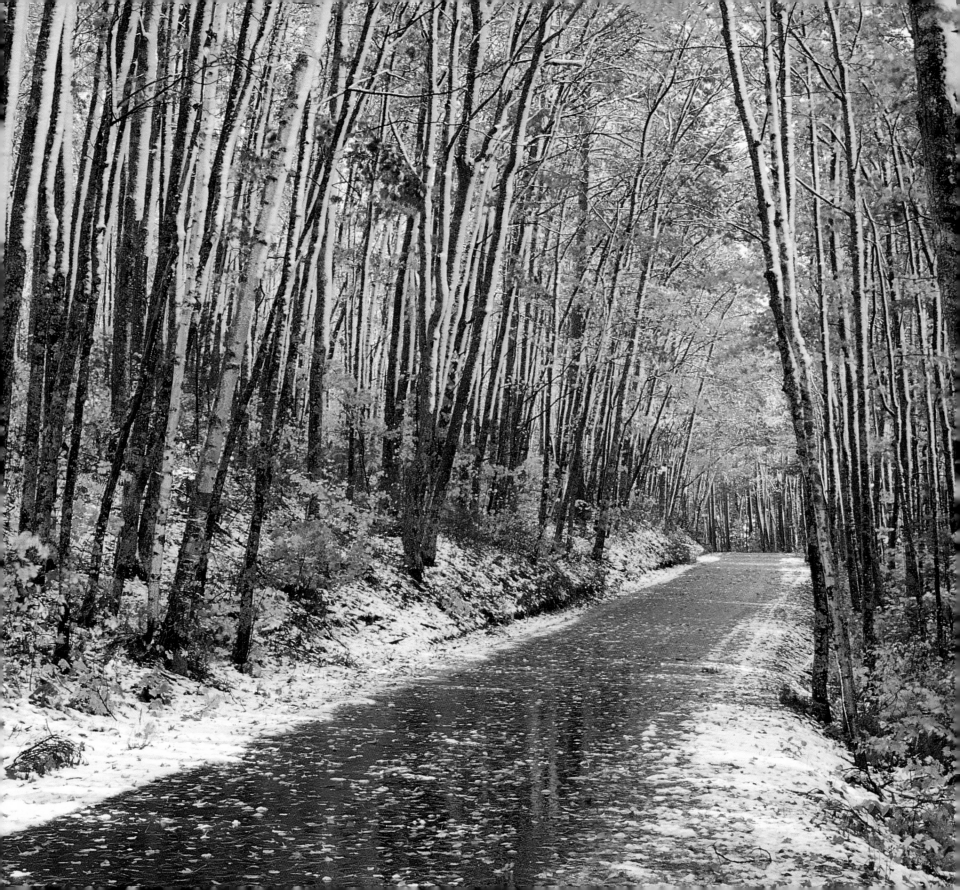

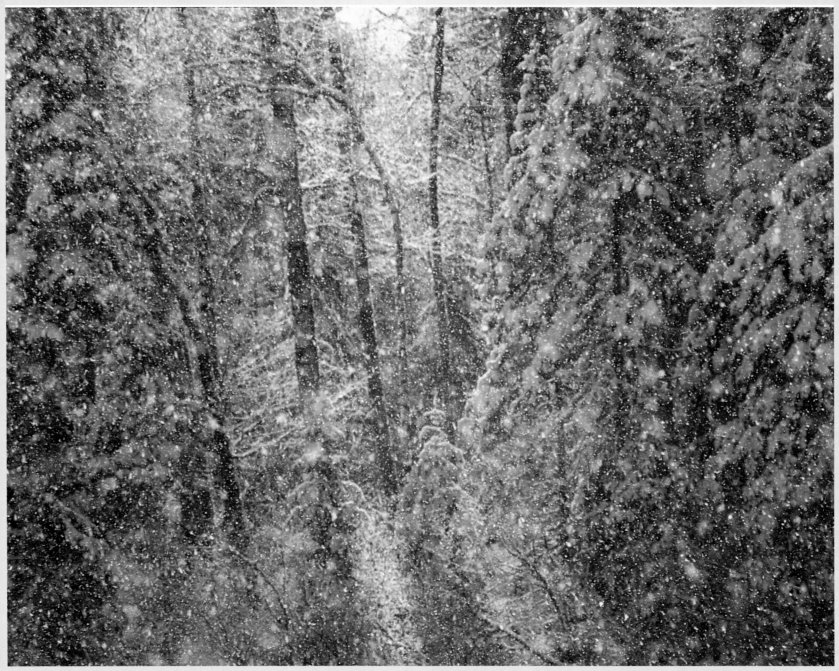

Winter

by Terry Daulton

My husband and I live in a small cabin on an island in the middle of northern Wisconsin's Turtle Flambeau Flowage. Winter's arrival is an especially dramatic time for us, as ice begins to surround our small world. During a nighttime trip to the outhouse we can hear the lake creak and groan as the sheets of ice thicken and grip the shores.

One year the ice formed silently on an extremely cold, calm night. The next morning we awoke to find our bay silent. When we walked down to the shore, we found the ice as clear as a window. We returned to the cabin for ice skates and were soon exploring a magical world. The normally murky depths had been transformed into a still, clear study in aquatic life. We saw plants three feet down lit by sunlight and swaying slowly in the mild current.

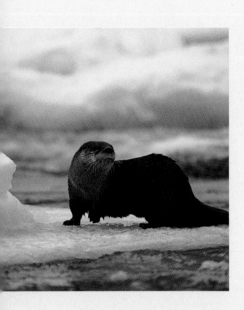

Bubbles of air released during photosynthesis were trapped under the ice in beautiful abstract patterns. As we skated above smooth stumps, we spotted walleye and northern pike hiding in the shadows and schools of minnows weaving along the bottom.

We skated up to a muskrat house and were surprised as the muskrat itself emerged from its underwater tunnel and swam toward shore. Air trapped in its fur escaped in tiny bubbles that bobbed under the ice, making a trail of the muskrat's retreat. We watched snapping turtles digging slowly in the muck, preparing their winter beds in slow-motion torpor.

The next night a deep snow fell and covered the lake, leaving us with only our imaginations to stray under the icy surface.

In his book *My Quest for Beauty*, psychiatrist and author Rollo May suggests that to be truly happy, humans need to create and be surrounded by beauty. He defines beauty as any experience that gives us a sense of joy and peace simultaneously. Beauty can be found in a work of art, an experience, a memory, a simple thought, or a natural scene.

For me, a direct connection with the natural world is the root of beauty, and the austere and challenging nature of winter creates an atmosphere of the exotic and lovely. The mystique begins building in late fall. The air takes on a sharp edge, and the rustle of bare branches against the steely gray sky catches your attention. The whitetail deer feel the call, and it awakens their romantic yearnings. Bucks scrape and rub their antlers on trees to mark their territories. Does go into estrus. Snowshoe hare and ermine shed their dull brown summer fur and spruce up in pure white winter fluff.

For us, a flock of geese calling overhead is a wake-up call. It's time to pull on a heavy wool jacket and head outdoors in search of adventure. Each day we watch for

the first telltale flakes of snow.

Although the onset is exciting, deep winter is perhaps the most magical part of the season. By January, temperatures in northern Wisconsin dip below zero with some frequency, but as the season progresses the cold actually seems to diminish. This may be due to the human body's ability to acclimate itself to ambient conditions. After two months in the increasing cold, we become impervious to temperature drops. However, the laws of physics also come into play. As air gets colder, it holds less moisture. The levels of moisture play a direct role in the cooling power of the air—thus drier air feels less cold than damp, misty conditions.

In addition, as winter deepens, upper atmospheric currents pull clear Canadian high-pressure systems over the northern part of the U.S., bringing deep blue skies and sparkling sunny days. While the temperatures drop, the sun brings immediate cheer to the northern landscape.

The sky holds the key to beauty in the winter. On clear days, any painter would admire the contrast between the stark white of the snow and the high blue heavens. Sunsets mirror their soft warm colors on snow, and as the sun drops below the horizon the sky becomes a deep, lush indigo flecked with stars. If you are lucky enough to live where northern lights play in the night sky, you can see the luminous greens, blues, and reds leaping and pulsing across the black heavens.

Deep winter is the time of soft, sculpted snowdrifts and frost-covered windows. In some ways it's a pity that our highly efficient, airtight windows have nearly eliminated the work of "Jack Frost." I remember the thrill of pulling back the curtains each morning as a child, eager to see what patterns the frost had created while I slept. I would pull out a pencil and paper and try to trace over the lines, but I always ended up smearing and melting the delicate patterns. In the quest for beauty,

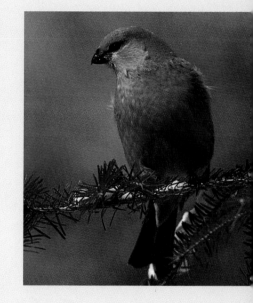

perhaps we should keep at least one small, leaky window in every house, so the intricate leaf, frond, and swirl of frost will not be lost to future generations.

Winter is also a season in which natural life is visible and dramatic. If you were to take a short ski from our cabin along the ice-covered shore, you would likely see a host of animal tracks. Red fox, coyotes, and wolves often cruise the near shore ice, using it as an easy highway that affords solid footing. Voles, shrews, and mice can be seen crossing meadows and popping out of tunnels in the snow. You might track a porcupine to its den in an old hollow tree, or encounter high drama in the woods by finding the kill site of a fisher that had been chasing a snowshoe hare. Winter often reveals the numbers, diversity, and secret lives of animals that are hidden from our view at other times of year.

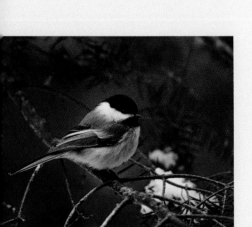

Late winter comes just as our enthusiasm for storm and ice is lagging. At our cabin, I always know when it arrives by the calls of our resident chickadees. During fall and early winter, chickadees travel in flocks that include a number of male and female birds. These flocks travel around a territory of about 20 acres and use three main calls to communicate—the *tseet, chebeck,* and *chickadeedee* calls. In late winter, the males start to give their territorial call, consisting of a two-note *fee-bee.* This sweet, clear tone is a signal that the males are beginning to compete for spring breeding territory.

In late winter the snow can get heavy and wet and perhaps lose some of its pristine whiteness. But this loss is tempered by the wan warmth you feel when you face the sun on a calm afternoon, and by the lengthened twilight when dusky tones suffuse the still-snowy world. Even the quiet drip of icicles melting off the roof lends a subtle music and a sense of waiting to the world.

Rollo May stated that beauty is the gateway to spiritual enchantment—that it

is in fact a pathway to the spirit. If this is true, the drama and vitality of winter may be a largely unexplored avenue in the quest for spiritual fulfillment. In his book *Reflections from the North Country*, Sigurd Olson wrote: "The great silences are beyond ordinary sounds of nature, a hush imbedded in a deep pool of racial consciousness."

Certainly winter can provide us with a deeper solitude and silence than is found in other seasons, when the rustle of leaves and the lap of water are omnipresent. Adventures in this landscape can bring you far more than cold toes. You may return from your north country encounters with a renewed sense of joy and peace—and a new connection with the sources of beauty that lie just beyond the doorstep.

Terry Daulton is a biologist and environmental educator. She has published articles in Wisconsin Academy Review, The Passenger Pigeon, *and numerous environmental newsletters, and co-authored scientific papers in a number of professional journals. Terry was for eight years the staff biologist and LoonWatch coordinator at the Sigurd Olson Environmental Institute at Northland College. She currently works as a biologist studying loon toxicology and behavior. In her spare time, Terry paints and writes at her remote log cabin home on the Turtle-Flambeau Flowage in Iron County.*

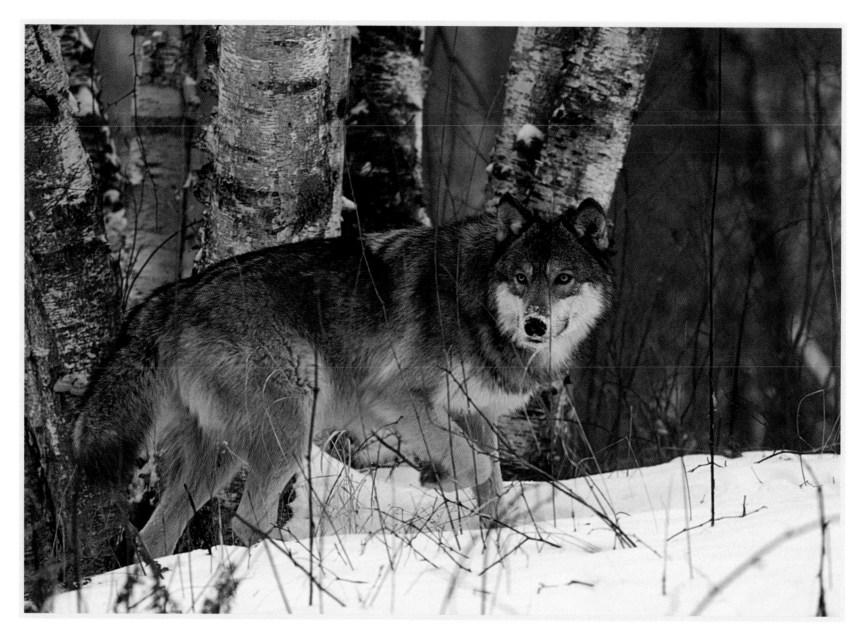

It's been a thrill observing the timber wolf, as the species re-established itself throughout the North.

Right: Mature pine forest like this reminds one what this area looked like before 150 years of logging.

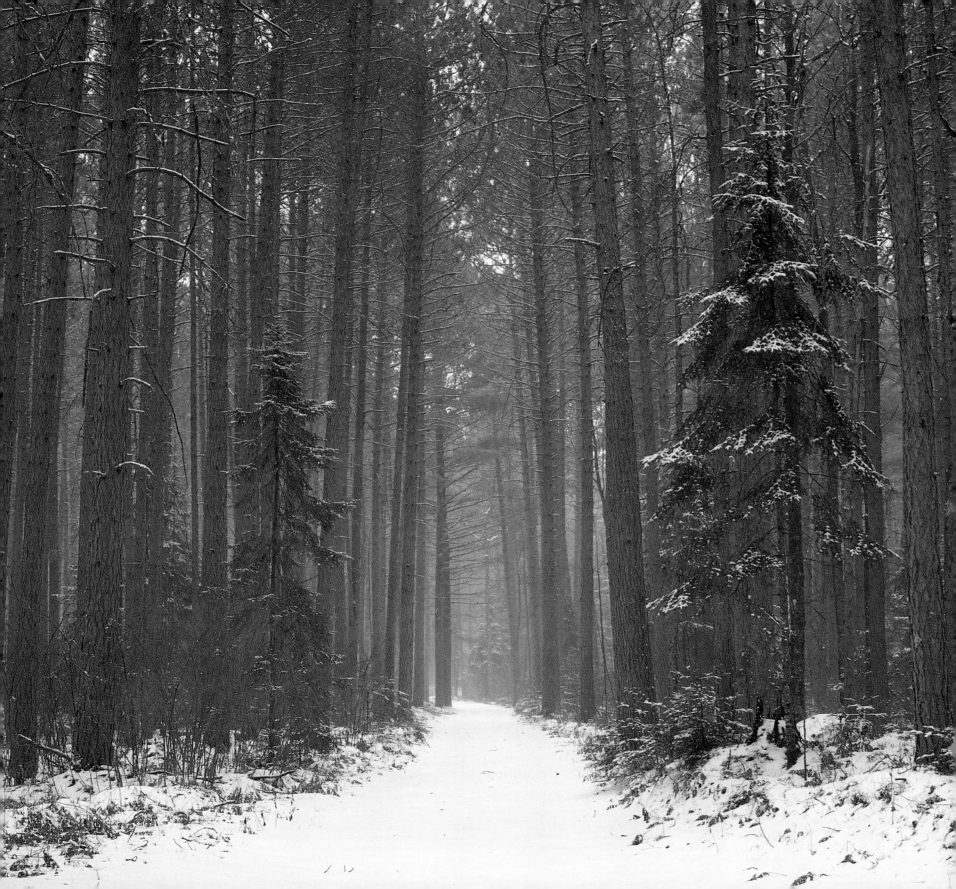

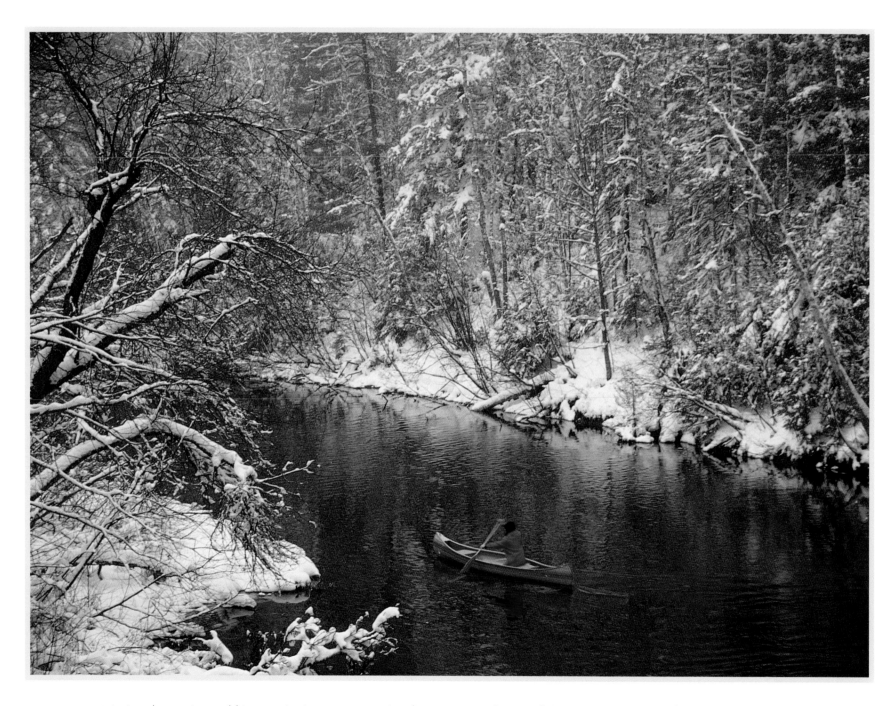

Die-hard canoeist paddling until the water gets hard. Right: Hoarfrost and fresh snow in Langlade County, Wisconsin.

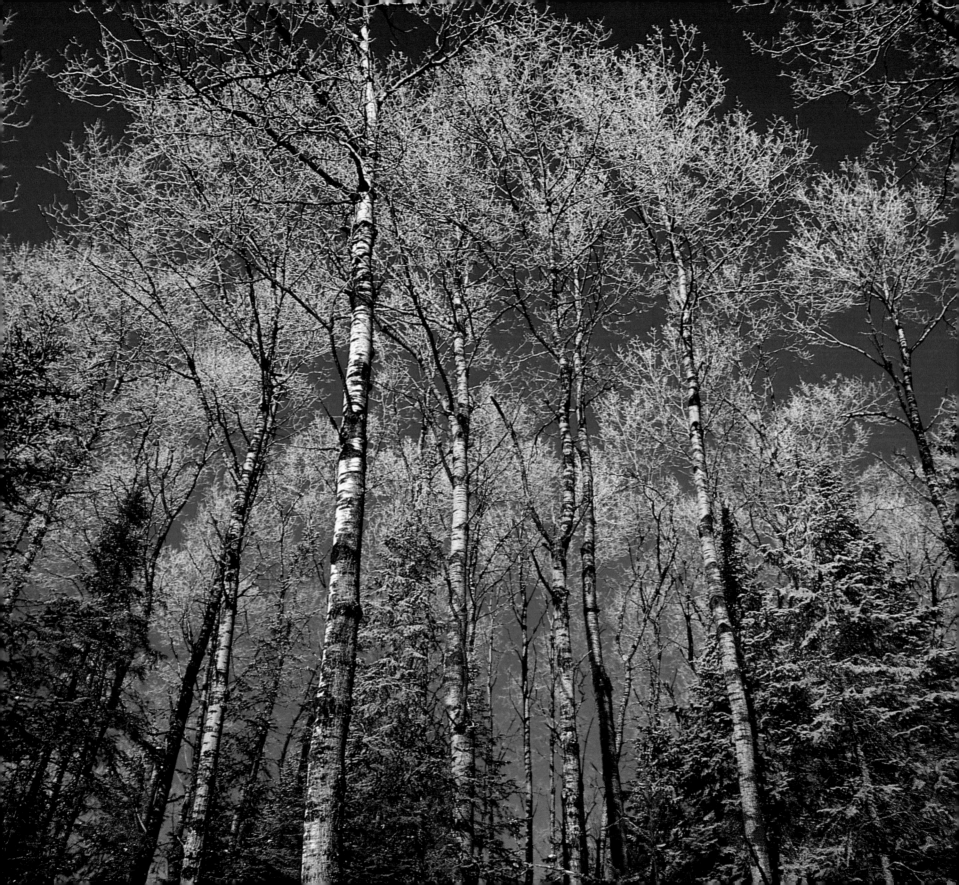

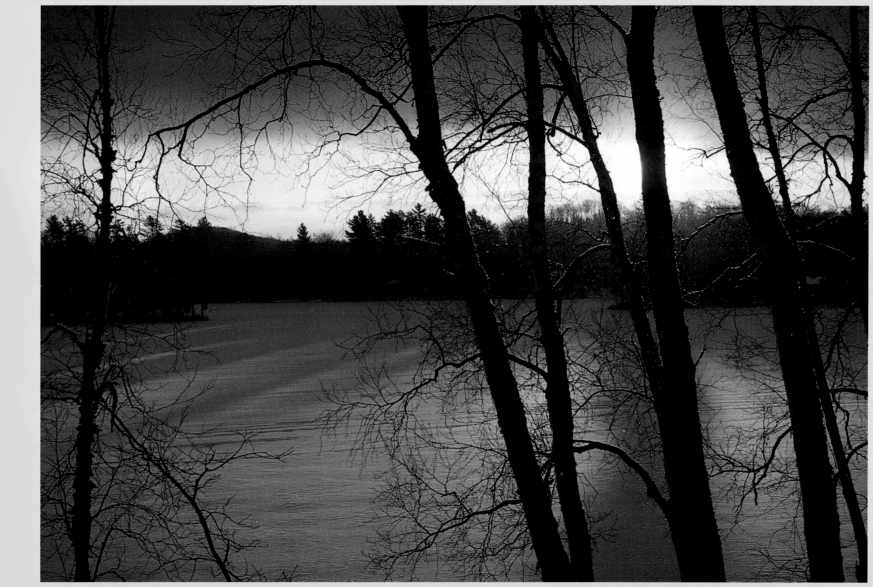

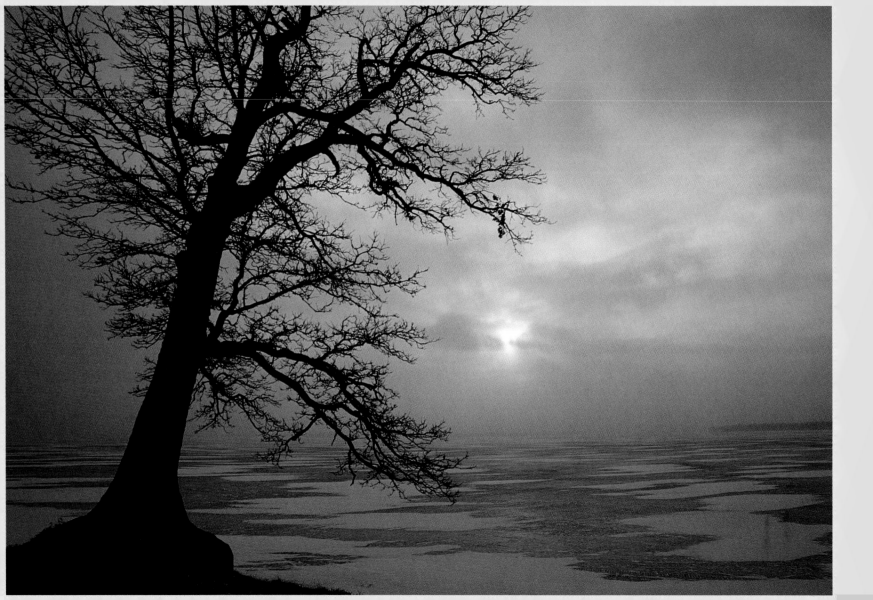

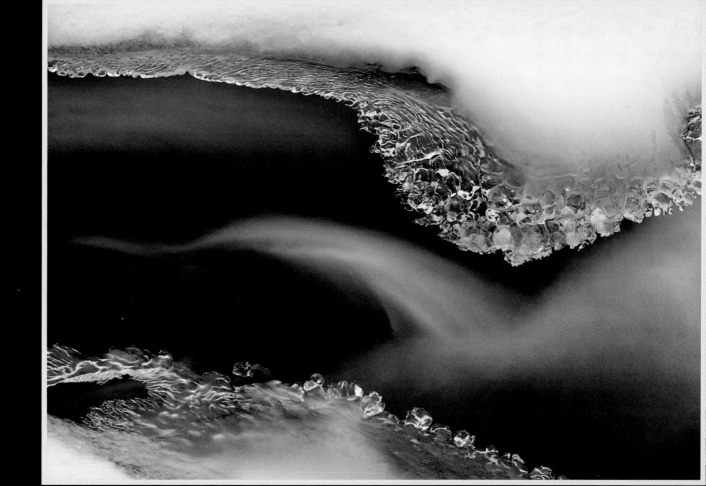

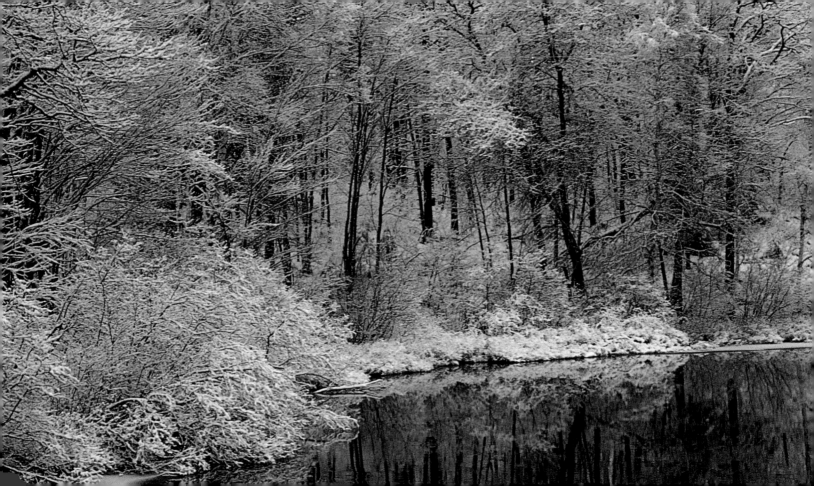

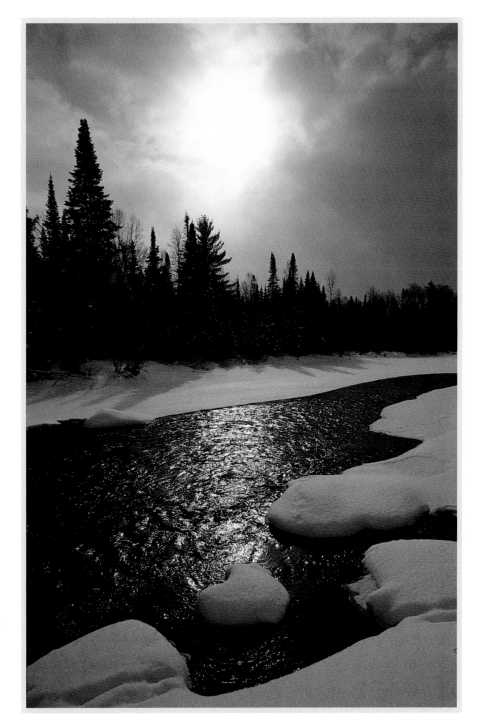

Left: There are many types of snow.
Wet snow that clings to branches
presents good photographic conditions;
Manitowish River, Vilas County.

Right: While photographing landscapes
is less frenzied than wildlife, good
light can be very fleeting on our
normally overcast winter days; Pine
River, Forest County.

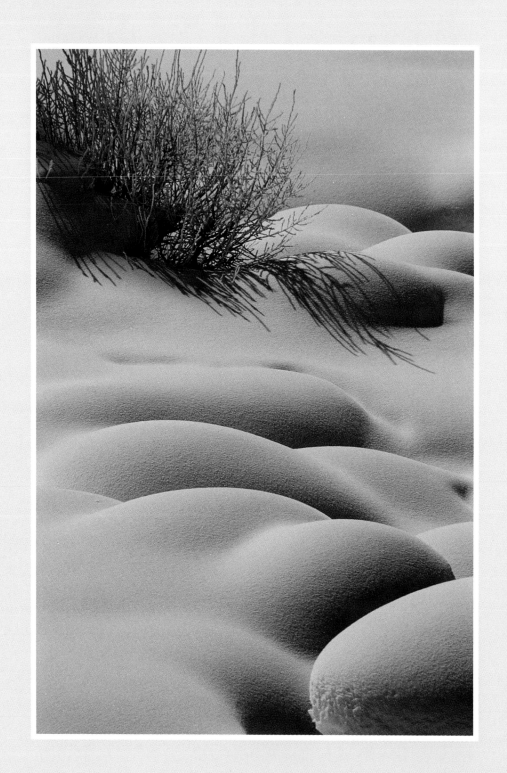

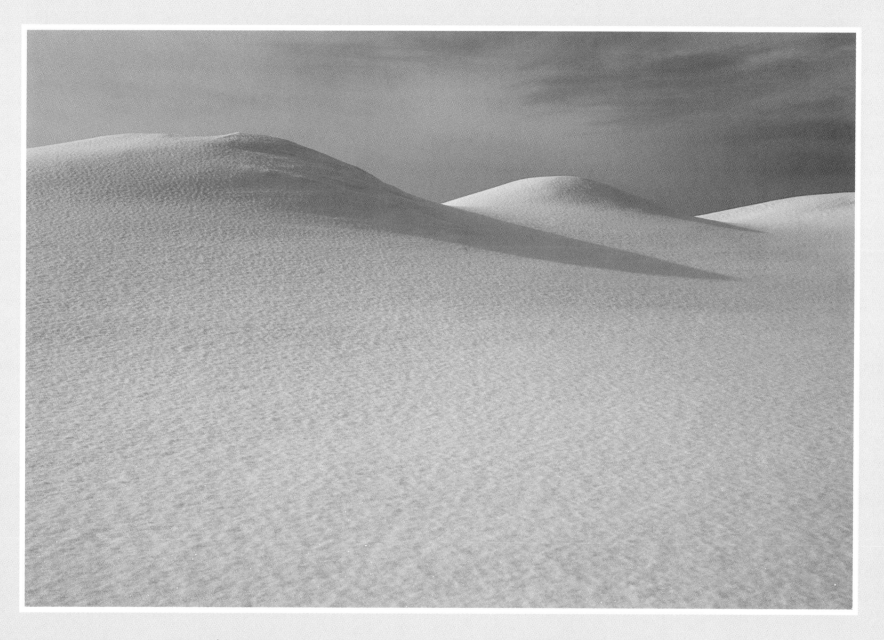

Snow dunes create sensual shapes on Lake Superior; Apostle Islands National Lakeshore.

Left: Slightly overcast light enhances the texture of soft snow sculptures.

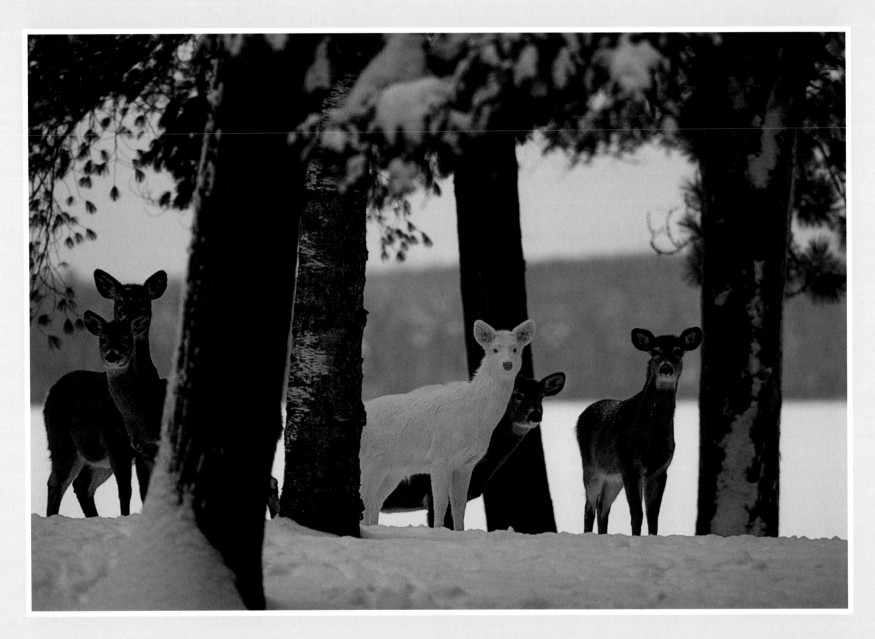

One of the gang

Right: A wolf nose knows.

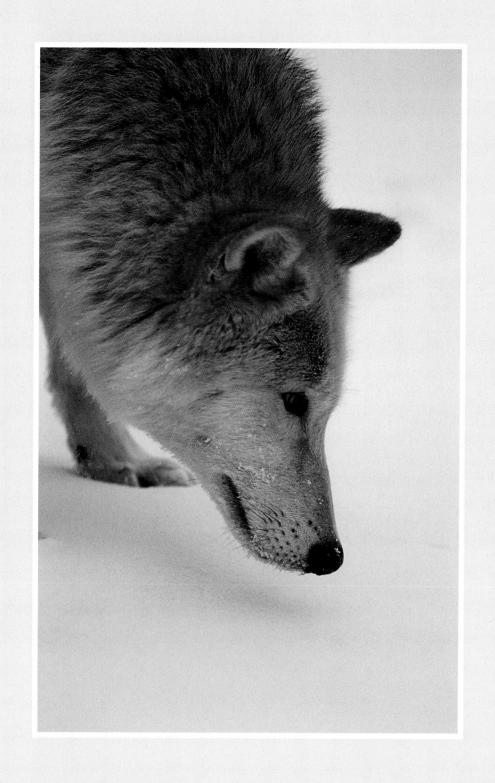

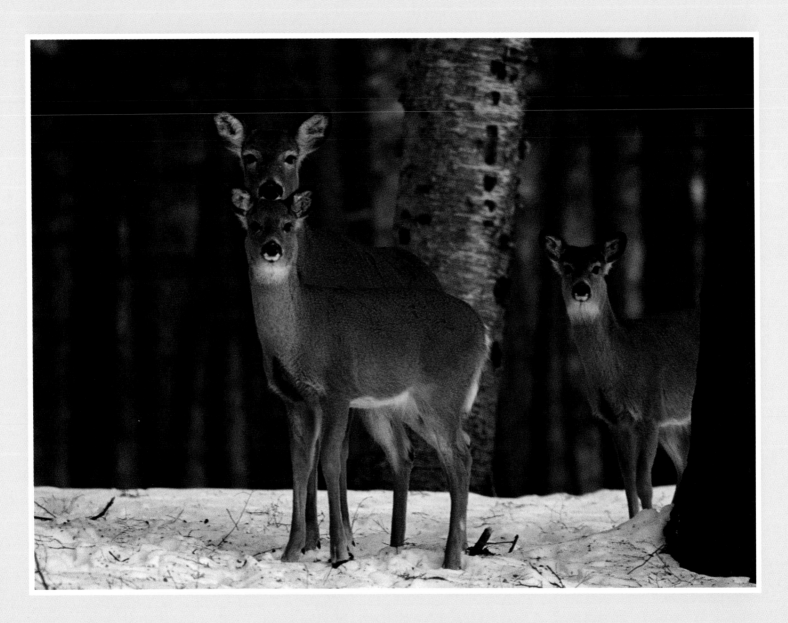

"Two heads are better than one."

Right: Milder weather and an expanding eagle population make winter sightings more common.

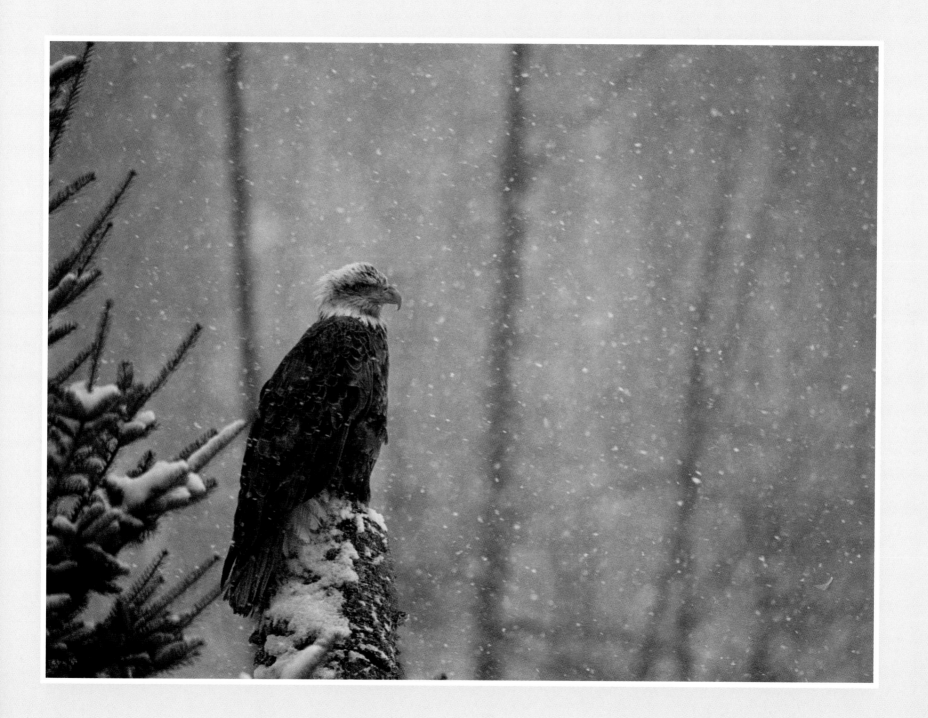

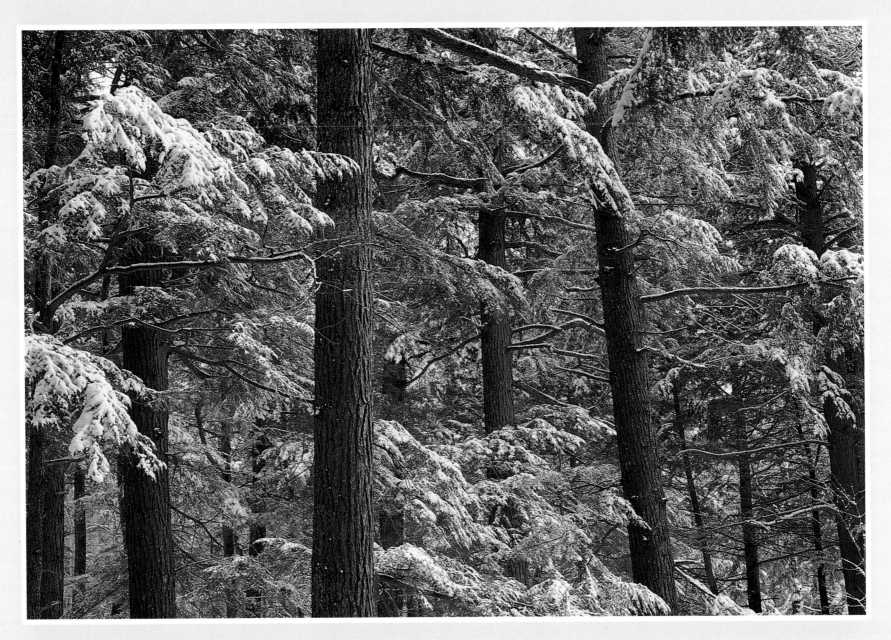

A mature hemlock stand — one of many important parcels preserved by the State of Wisconsin for the enjoyment of all citizens.

Right: A large wolf looks out with the intense eyes of a predator.

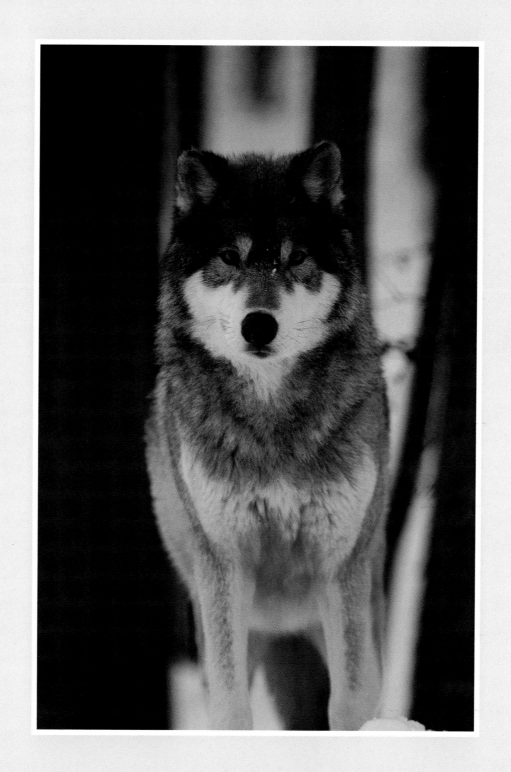

Ice appears in an endless array of shapes, sizes and textures. Other than cold fingers and toes,
there's no reason to put the camera away and miss winter's beauty.

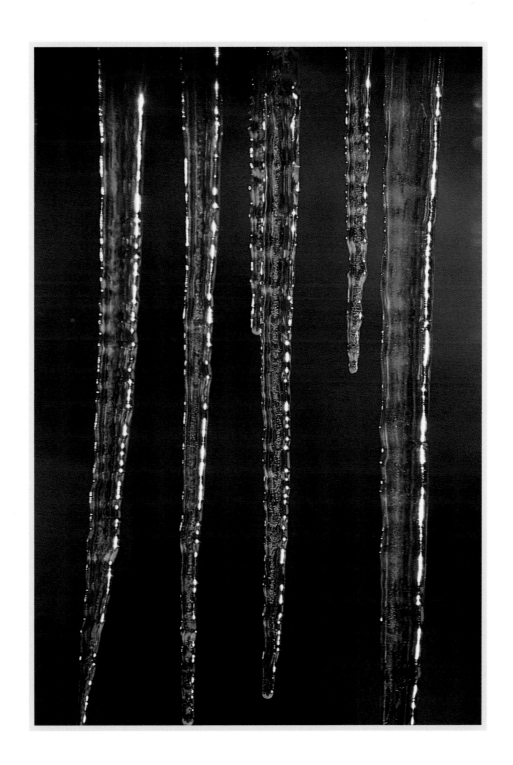

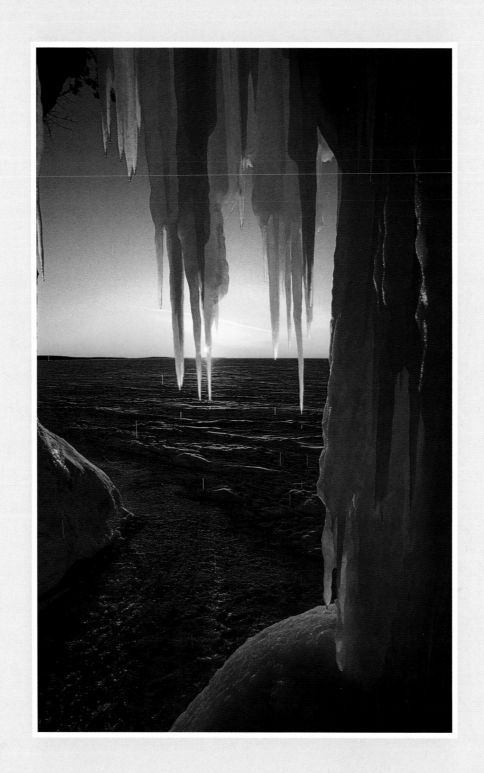

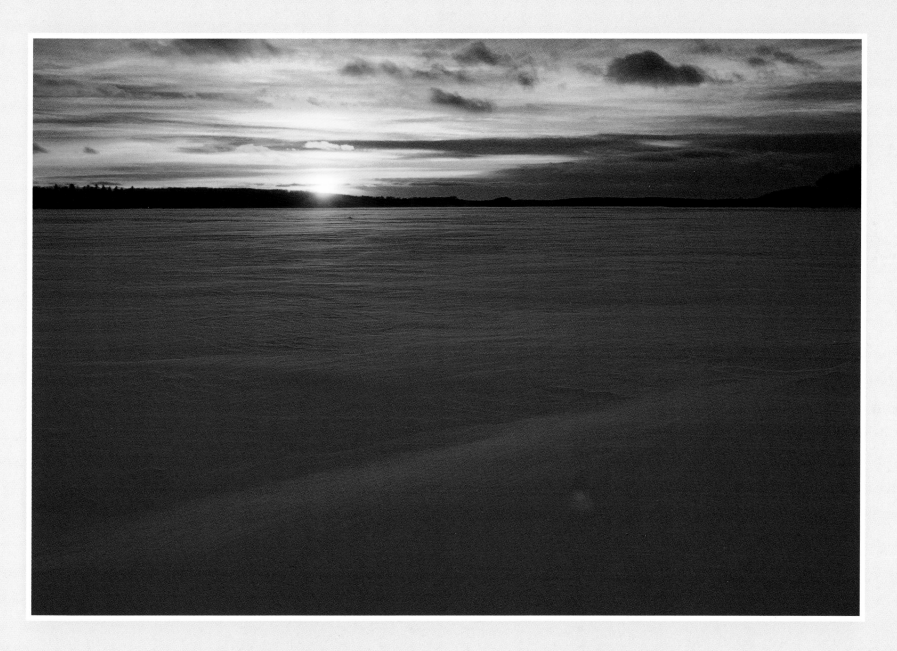

Warm sunset colors at the end of a brutally cold winter day; Willow Flowage, Oneida County.

Left: Melting icicles and setting sun; ice caves on the shore of Lake Superior.

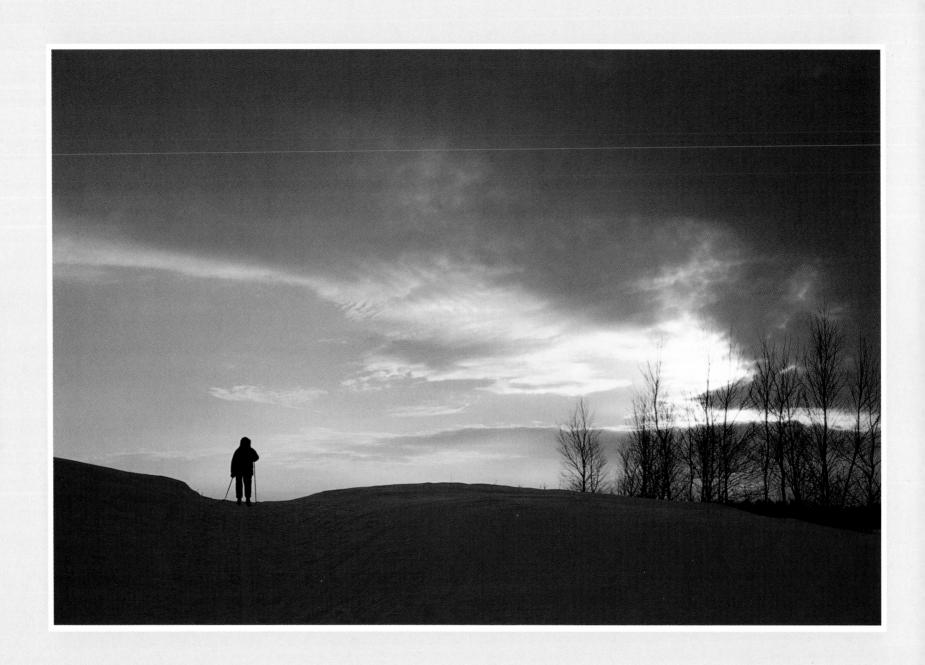

Skiing into heavenly skies at the end of a Northwoods afternoon.